HISTORIC RESTAURANTS

of

CAPE COD

HISTORIC RESTAURANTS
of
CAPE COD

· · · · · · · · · · · · · ·

CHRISTOPHER SETTERLUND

AMERICAN PALATE

Published by American Palate
A Division of The History Press
Charleston, SC
www.historypress.net

First published 2017

Manufactured in the United States

ISBN 9781467119436

Library of Congress Control Number: 2017931812

Notice: The information in this book is true and complete to the best of our knowledge. It is offered without guarantee on the part of the author or The History Press. The author and The History Press disclaim all liability in connection with the use of this book.

Dedicated with love to my Grampa John Sullivan, my hero, my role model and the definition of what a man should be—thank you and I love you.

CONTENTS

CONTENTS

ACKNOWLEDGEMENTS

This project took a lot of time, research and hard work. It would not have been even remotely possible without the help of the following great Cape Codders: Meg Costello, Museums on the Green Falmouth; Danielle Jeanloz, executive director, Atwood House Museum, Chatham; David Dunlap, Building Provincetown Website; Betsy Wheeler, Barnstable

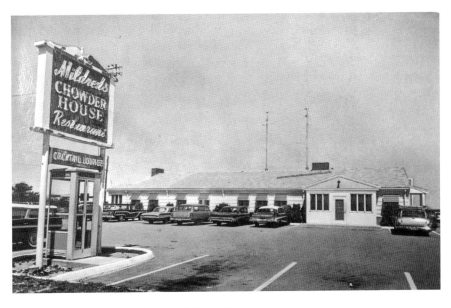

Mildred's Chowder House. *Courtesy of Sturgis Library.*

Historical Society house administrator; Tom Dott, owner, Lamb and Lion Inn, Barnstable; Dan Bayley, Sandwich Historical Commission; Duncan Oliver, Historical Society of Old Yarmouth; Gloria Green, Harwich Historical Society volunteer; Mary Sicchio, Bourne Historical Society; Cynthia Ward, owner, Chapin's Restaurant; Don McKeag, owner, Asa Bearse House Restaurant; Rose and Bob Gianferante, who owned the Yankee Clipper; Sylvia Leonard, whose family owned Rose's Restaurant; Jean Young, assistant archivist, Chatham Historical Society; Joe Burns, reporter for the *Register* in Dennis; Bob Arnold, WellfeetOsprey.com; Ed Maas, owner of the Orleans Inn; Joe Jamiel, owner of Christine's; John and Maxine Zartarian, owners of the Paddock; Nicole Muller, reporter for the *Register* in Dennis; Diane Dexter, musician and pianist at Dorsie's; Tom Davis, the Business Exchange Real Estate; Peter and David Troutman, owners of Scargo Café; Alexandra Grabbe, Grabbing Alexandra Blog; Sturgis Library in Barnstable; George "Dorsie" Carey and his wife, Louise Houston; Mr. Johnny Yee; Marty Bloom, who owned Bloom's Prime Rib House and Starbuck's; Peter Cutler, Town Taxi; Stacy Apostol, whose family owned Sword and Shield; Gail Nessell Colglazier, Orleans Historical Society; Nick and Sophie Joakim of the Mayflower Restaurant; Ed Woelfle, former executive chef at the Cranberry Moose; Mary Ann Taylor and Dale Setterlund of Mari-Jean's; Tammi Mason of the Brewster Health Department; author Paul Hensler; Jay Bartolomei, whose grandparents owned Danny-Kay's; Karen North Wells, Underground Art Gallery; Jane Klimshuk, whose father owned Reno Diner; Anna and Bruce Woodland, owners of Northport Restaurant; Laura Hopper-Fish and Antwan Chigare, owners of Laura and Tony's Kitchen; Brian Dunne of Aesop's Tables; William Kaser, whose father owned the Cleaver; Bonnie Fellows, whose parents owned Bill & Thelma's; Barbara Lind and Susan Kettell-Lind of My Tinman Diner; and Jen Dow and Judy Shortsleeve of *Cape Cod Life* magazine.

I also could not have undertaken this project without the love and support of my family. My Grampa John Sullivan, who owned Sullivan's Donut Shop, and his wife of more than seventy years, my Nina Rosemarie Sullivan; my mom, Laurie; my dad, Jack; my sisters, Kate, Lindsay and Ashley; my brother, Matt; my nieces and nephews, Kaleigh, Emma, Liam, Landon and Lucas; my stepfather, Chris Serpa; Nana Serpa for her help on Provincetown; my brothers-in-law, Chris and Jim; my uncles, John, Steve, Bob and Eric; my aunts Susan, Emma, Kelly and Amy; and my cousin Donna.

I also have a great support group of friends who deserve to be recognized for all of their help with this project. My mentor and good friend Bill

DeSousa-Mauk, without whom I literally would not have gotten this project, as well as Steve, Emily, Deanna, Mike, Fitzy, DJW, Rob, Meg, Judy, Barbara, Kristin and Dana, Dawn, Tony, Freshy, O'Neil, Debbie, Maui, John Z, Barry, Monique, Tiffany and Sean, Kaylin, Shayna and the Wolfpac (Greg, Mike, Tuna and Brewster).

INTRODUCTION

Cape Cod is 339 square miles of beaches, forests, ponds, rivers and marshes. It is home to some of the most breathtaking scenery on this planet, which is one of the reasons why the population there triples in size during the height of the summer tourist season. They come for those beaches, they come for those historic sites and they come for a slice of paradise that is not so easily found. Perhaps most of all, though, the hundreds of thousands of yearly visitors come to Cape Cod for the food.

In the last century, thousands of restaurants have come and gone on Cape Cod. Some burn out in the blink of an eye, while others stand the test of time and leave an indelible mark on the fabric of the Cape. A few of those landmark spots are still up and running to this day, carrying the torch for so many places and owners who fell by the wayside. However, those are few and far between. For the most part, those beloved restaurants of yesteryear have faded with the passage of time. For every Thompson's Clam Bar there are hundreds of places that have long since faded into oblivion.

According to an oft-cited Ohio State University study released in 2005 by H.G. Parsa, John T. Self, David Njite and Tiffany King, 60 percent of restaurants do not survive past their first year, and 80 percent go under within five years. It is much more common for an establishment to open and close in the blink of an eye before it has the chance to leave a mark on a region.

Those cherished places may not be standing anymore, but they remain alive in the memories of longtime Cape Codders and visitors over the last

several decades. It takes great customer service, tremendous cuisine, unique décor and a little *je ne sais quoi* to turn an ordinary everyday restaurant into an icon. This book is a loving tip of the cap to those establishments that brought years of good times and great food to those lucky enough to live on or visit this wonderful peninsula.

There will be some history, photos and maybe some anecdotes to stir up memories or make one wish they had the chance to go back and visit these places.

Aesop's Tables

Address: 316 Main Street, Wellfleet
Years Active: 1969–2004

One part fine dining, one part casual, a little bit of Cape Cod style and a whole lot of creativity—these elements are some of what went into making Aesop's Tables a destination for countless locals and visitors for more than three decades. Situated on a hill on Main Street and shaded by a pair of towering oak trees, it was a modern throwback mixing intimate dining with superb food that tantalized and delighted. It is no wonder that it was routinely referred to as Wellfleet's finest restaurant.

The story of Aesop's Tables goes back to the nineteenth century, when the building itself was erected. The Greek Revival home was built in 1805 for bank president Isaiah Young. The home would become known as the summer residence of Massachusetts governor Channing Cox. Cox governed the state from 1921 to 1925, becoming the first leader of the state to use radio to communicate with the people. At one point, Cox even hosted President Calvin Coolidge, whom he had succeeded as governor, at his summer governor's mansion. Later, in the late 1950s and '60s, it would be known as Mrs. Brady's Boarding. However, the house on the hill was still to gain its greatest notoriety.

The former governor's summer home nearly remained a private home. In the late 1960s, Ciriaco Cozzi, co-owner of Ciro & Sal's in Provincetown, had gone to Wellfleet to look into possibly purchasing the estate. When he

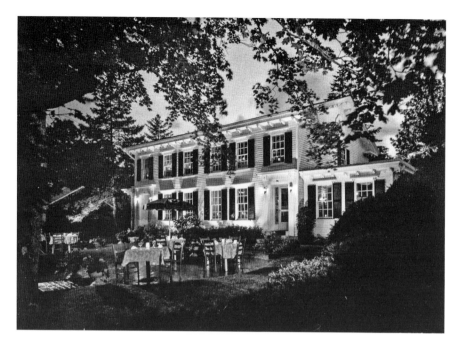

Aesop's Tables, Wellfleet. *Courtesy of Brian Dunne.*

decided not to buy it, Cozzi returned to his restaurant and suggested to one of his cooks, Cliff McGee, that he and his wife should buy it and turn it into a restaurant of their own. In 1969, Cliff McGee and his wife, Barbara, would do just that, turning the historic home into Aesop's Tables. It would not be just any restaurant, though. The McGees would use the unique structure of the home to make it into a dining experience not easy to reproduce.

Open from May through October, Aesop's Tables had six dining rooms. Some of them were smaller, such as the Fireplace Room, the Plum Room (named for its color) and the Summer Kitchen, which was open-air, screened in and, in fact, used as a kitchen by former owners during the warmer months. Even the larger main dining room felt spacious yet intimate due to a divider that reached the ceiling. The porch included turquoise and black directors' chairs, and the upstairs bar, added in 1973, created a more laid-back atmosphere, complete with Victorian sofas. Aesop's Tables felt like fine dining in one's own home.

The mixture of upscale and casual was seamless. This was due in large part to the care and attention to detail of the staff, from the owners all the way down. Everyone who worked inside the walls wanted to make sure that

customers enjoyed their stays and their meals. As great as the service was, the food was every bit as much the star at Aesop's Tables.

In 1983, Brian Dunne and his wife, Kim Kettler, purchased the establishment from the McGees and began carving their own notch in the legacy of the historic home. They made some minor renovations to the bar, did some painting and modernized the kitchen before setting their sights on the menu. After attempting a season of "nouvelle cuisine," they switched to new American cooking that focused on fresh ingredients. Some of the vegetables were grown at the couple's home, while others came from a local organic farm—a relatively new concept in the 1980s. Much of Aesop's seafood would come literally right off the boat, with the oysters and fish being delivered late in the evening after fishermen returned from the harbor.

This attention to the freshness of the menu's ingredients helped make some of the items classics and quite popular with the customers. There was the immensely popular artichoke dip appetizer. In addition to the duck, steak and chicken served, perhaps the most widely enjoyed choice on the menu was the Poseidon Pasta, which was laden with several types of seafood. There was also a light-on-breading, big-on-flavor stuffed flounder that could be a close second. For dessert, there was nothing better than the Death by Chocolate. It was a dessert so big it needed to be trademarked.

Aesop's Tables was seasonal, open from Mother's Day through Columbus Day. The owners would staff locally as best they could, even having some who worked with them all four years of high school and then all four years of college. The closing time changed with the debut of another Wellfleet tradition: Oysterfest. The first festival arrived in 2001 and was much smaller and more local. Aesop's would stay open through the festival, helping out where it could and even using its remaining food to create meals for the organizers, volunteers and visitors to the gathering.

People came from near and far—some every day, some for big occasions like wedding rehearsals and birthdays. It was a perfect spot to impress a date and won Most Romantic Restaurant several times in *Cape Cod Life* magazine. A most special accolade came when *USA Today* wrote a positive piece about Aesop's Tables. However, it was chosen as the Best Children's Restaurant in Wellfleet. This was due to the fact that the management had asked a group of local third graders to help design a children's menu. An outdoor patio was added in the early 1990s as soon as outdoor dining was allowed in Wellfleet, adding another dimension to the town's finest restaurant.

As the twentieth century ended, it got harder and harder for Aesop's Tables to keep going. The season was too short to enable the popular, but

upscale, restaurant to make money. Problems in Wellfleet with town water and septic services sapped the fun out of running the business for Brian Dunne. He decided to sell in 2004. The historic home was purchased by the Barry family, who had successfully run Moby Dick's in Wellfleet for twenty-four years. In 2005, after some interior renovations, Aesop's Tables was rechristened Winslow's Tavern. As of 2016, Winslow's is still going strong, adding another chapter to the historic Isaiah Young House.

It takes a strong dedication to customer service, a great menu, special décor and a little *je ne sais quoi* to become one of the legendary restaurants of Cape Cod. For more than three decades, Aesop's Tables did all of those things, which is why it is still so fondly remembered by those who were lucky enough to dine and work there.

ASA BEARSE HOUSE

Address: 415 Main Street, Hyannis
Years Active: 1976–1991

This spot has a history rich and deep, though it might be overshadowed by the history of its most famous owner. The Asa Bearse House on Main Street in Hyannis got its start as a sea captain's home. It was built in 1840 for Captain Asa Bearse, who was a merchant out of Cotuit. He spent seventeen years at sea, fourteen of them as a captain. The home itself would have been well known and historic if Bearse had been the sole owner; however, he was only the first in a line that continues to this day.

In 1879, local doctor Samuel Pitcher purchased the property for his home. Pitcher was well known at the time for inventing a medicine called "castoria," which was a laxative compound used as a substitute for castor oil. After his death in 1907, the home was sold and became the Beechwood Inn. The inn was a popular bed-and-breakfast into the 1970s. It was around this time that the Asa Bearse House would get a second, and even more famed, life.

Don McKeag came to Cape Cod in 1953, when his father, "Lefty," bought the Skipper Restaurant, which still stands on South Shore Drive in South Yarmouth. McKeag was a busboy, dishwasher and anything else he could do to help. Business was affected by the arrival of two hurricanes—Carol and Edna—in back-to-back months in 1954. Though he did not stay at the Skipper McKeag, remained involved in the local business scene.

In 1968, he became the first piano player at Baxter's in Hyannis, a job he would hold for six years. McKeag's first solo venture was to run the Marstons Mills Cash Market on Route 149. He opened it in 1973 and maintained the business for three years. It was in 1976 when McKeag saw an opportunity he had to take.

As a real estate agent, Don McKeag went out to showcase the Beechwood Inn property, which had been sold in 1975 to a computer technology couple. They already wished to sell it again a year later. Upon seeing the property, McKeag realized that it had the potential to be transformed into a restaurant and nightclub, so he bought it himself. This would be his first—but not his last—restaurant.

The first major hurdle he had to overcome was getting a coveted liquor license in the town of Hyannis. Once that was secured, he also had to fight tooth and nail to get the outdoor seating, which would come to be a very popular feature of the Asa Bearse House. Soon after it opened in 1976 it became a hit, although some people did not approve. "I remember some of the little old ladies who used to come in when it was Beechwood," McKeag said. "They didn't like that Asa Bearse was selling liquor. But then the old ladies who liked to drink started showing up instead!"

The establishment was a popular spot for fine dining and entertainment. On many nights, jazz greats Dave McKenna and Lou Colombo could be seen and heard playing their music. In fact, McKeag can remember a certain night when an all-time jazz icon sneaked into the Asa Bearse House.

"Dave [McKenna], Lou [Colombo], and my Dad 'Lefty' were playing on stage," McKeag reminisced, "and one of them spots Dizzy Gillespie in the back with his trumpet. They got him to come up on stage and play with them."

It was amazing moments like this one that set the tone for this restaurant and nightclub. In 1981, McKeag one-upped himself by purchasing Asa Bearse's old barn, which sat next door to the restaurant. He used this property to create his wildly popular Reading Room. He sank more than $100,000 into the room, which included more than 3,600 books, antique pieces and cut glass. The risk was worth it, as the Reading Room would be named "The Most Beautiful Room on Cape Cod" by *Yankee Magazine*.

McKeag had a trusted core of staff who helped him keep the wheels turning at Asa Bearse House, including Marylou Robinson, who managed the establishment. She would go on to own the original Marshside Restaurant in East Dennis from the mid-1980s until 2008.

In 1983, McKeag purchased another Cape Cod landmark, the Flying Bridge in Falmouth. Founded in 1957, this spot is still going strong as of

2016. He would end up selling the Asa Bearse House in 1984 to focus on his new venture. However, McKeag's time at the Flying Bridge would be short-lived, as he sold it a few years later—a move he regrets to this day.

The Asa Bearse House would carry on through the 1980s, even becoming property of McKeag again as the 1990s began. Since McKeag sold it for a second time in 1991, the property has undergone several ownership changes. In the past two decades, it has been known as the Ocean Grill and the Blue Room, Asa Grill and Grille 16 at Asa Bearse House (owned by Boston Bruins legend Derek Sanderson), Timmy B's and Prova Brazil.

Today, Don McKeag can be heard weekly on his Saturday radio talk show on 95.1 WXTK. As of 2016, the spot where the Asa Bearse House once stood is occupied by Torino Restaurant and Bar.

THE BEACON RESTAURANT

Where it's a treat to eat.

Address: 720 Main Street, Hyannis
Years Active: 1936–1968

M any years before Thompson's Clam Bar became the standard bearer of popularity among Cape Cod restaurants, there was another spot that matched what the legendary Harwich establishment would do in the latter half of the twentieth century. That place was The Beacon Restaurant. Located in the West End section of Hyannis, The Beacon attracted visitors to Main Street decades before the Melody Tent. It was the patriarch of all the major restaurants that followed.

This giant of the restaurant industry on the Cape was created by Edward Kneale in 1936. Looking for a new venture, he came to Cape Cod after retiring from the manufacturing business in New York City. Kneale settled seasonally in the high-class village of Oyster Harbors and wintered in Florida. The spot he chose was land that was once owned by famed nineteenth-century sea captain Alvin S. Hallett, who once sailed from Boston to San Francisco in 104 days and then back again.

Before it was even built, The Beacon was being hyped as the "best restaurant on the Cape" by local newspapers. With architectural plans drawn up by Walter Gaffney calling for the structure to be set far back from the road to allow room for ample parking and beautifully landscaped grounds, Kneale's spot would be as modern as a restaurant could be pre–

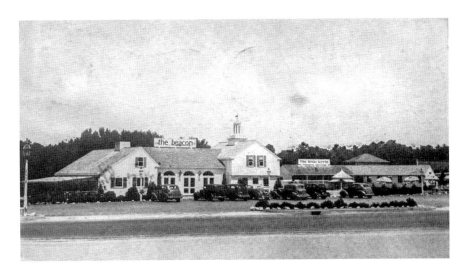

The Beacon. *Courtesy of Sturgis Library.*

World War II. Kneale erected a large white building that caught the eye of those passing by—Hyannis in the 1930s was nothing like what it looks like now. The Beacon would seat seventy-five people, which was unheard of in a time when many restaurants were little more than a counter and a few small scattered tables.

Its success was immediate. In April 1936, two dinner parties were held to celebrate the opening of The Beacon. On each night, nearly one hundred people from Hyannis and then Osterville enjoyed inaugural meals at this grand establishment. More than two hundred requests for reservations had to be declined due to the capacity of the restaurant. Its five dining rooms and seventy-five-seat capacity were not enough.

The first year, The Beacon opened as a seasonal restaurant in late April. The patrons dined on simple favorites like hamburgers, hot dogs, chicken pie, fish chowder, Beacon rolls and homemade ice cream. One item, however, needed to be revisited, and that was the clam chowder. Being from New York City, Kneale brought with him the idea of Manhattan clam chowder, which is tomato-based rather than the cream-based chowder New Englanders were accustomed to. The restaurant's popularity was immediate and overwhelming, and Kneale knew he had to do something to allow more people access to his establishment.

Kneale added The Beacon Snackerie due to the high demand for seats at his establishment. This outdoor dining area next to the main restaurant could accommodate up to 150 people and was adorned in blue and white. It

opened in July 1936 and became another instant hit. The restaurant closed in late September after serving as many as 1,800 people per day in its first season, rivaling the peak of Thompson's Clam Bar.

Kneale promised that the next year would see improvements to The Beacon—a restaurant that was already exceeding what any restaurant had done in the past on Cape Cod. So successful was the Snackerie idea at The Beacon that Kneale opened a sister spot at his winter home in West Palm Beach, Florida, in time for Christmas 1936.

The year 1937 saw The Beacon become a year-round establishment and Kneale become a year-round Cape resident. He and his family rented out a cottage on Long Beach in Centerville. That same year, Kneale acquired a liquor license for The Beacon, the oldest liquor license on Cape Cod. It was little more than three years since the end of Prohibition.

A new enclosed dining area at the Snackerie allowed for up to two hundred people to be served at once. Business was only helped by the addition of a full-service Gulf gasoline station directly across the street. The two worked in tandem, with customers having their cars worked on going across the street to dine at The Beacon while they waited.

The Beacon had become the biggest name in Cape Cod dining after only two years, and it would not let go of that mantle easily. In 1938, Kneale began to offer special breakfast, lunch and dinner combos beginning at fifteen, thirty and forty-five cents, respectively. Friday nights became all-out dance parties at the Snackerie. Music was pumped out from The Beacon through loudspeakers, and folks could dance, if the urge should take them, that is. Business increased by a third in The Beacon's third year. In 1940, Kneale opened The Beacon Junior in Sagamore, up near the bridge. His imprint established, Kneale left The Beacon in the capable hands of his son Edward Kneale Jr. and headed up to Boston to run the Hotel Puritan in the early 1940s before ending up back down in Florida in the early 1950s.

The Beacon continued to serve loyal customers into the 1960s. By then, many new restaurants and attractions had come to claim some of the pie that the restaurant once dominated. Once things changed in Hyannis, they would change quickly and often. In 1968, The Beacon ceased to be. In the time since, the property became the Brass Rail, Slade's of Boston, MD Armstrong's, Cranberry Boggs and the Hyannisport Brewing Company. As of 2016, the property that housed the original king of Cape Cod restaurants lies vacant.

THE BELLOWS

Address: 28 Falmouth Heights Road, Falmouth
Years Active: 1933–1948

In June 1933, Cape Cod was a very different place than it is today. The current Sagamore and Bourne Bridges were two years away from being constructed; in their places stood two drawbridges built in the 1910s. The Mid-Cape Highway was two decades from existence; Route 6A and Route 28 were the main roads carrying people all over. There was no television, and there were no radio stations. According to the 1930 census, the year-round population was a mere thirty-two thousand or roughly twelve thousand less than Barnstable alone in 2014. It was a much different world then, except for one thing: food. In any time, people have to eat.

In 1933, just as the Great Depression was taking hold, a new eating establishment opened up in the then-quiet town of Falmouth. It would be simply known as The Bellows, and its owner would make it one of the first landmark restaurants on Cape Cod.

Tekla, or Thekla, Hedlund was born on Long Island in the town of Lynbrook. She first came to Cape Cod during the Roaring Twenties, summering in Centerville and beginning to establish her reputation for creating and serving delicious food. Hedlund operated the Lustre Tea Room on Main Street in Centerville for five successful years before deciding to ply her trade in Falmouth.

Another tearoom, which were popular during the pre–World War II era, was what Hedlund had in mind, although it soon outgrew anything she had previously planned. Even back then it was quite difficult to open a new business, and Hedlund found herself rejected by the town before it finally agreed after a second application to allow the building to be constructed on Falmouth Heights Road. Local builder John DeMello erected the tearoom, and Hedlund was ready for the summer season in June 1933.

Word spread slowly the first season. Hedlund relied on her reputation from the Lustre Tea Room and positive feedback from those customers who took a chance on her new establishment. Those who did come in for breakfast, lunch or dinner were treated to fine cuisine, including popular items like chicken pie, corn fritters and even lobster. Local lobsterman Sam Cahoon, who had provided lobsters to Hedlund at Lustre, caught them for The Bellows as well. This was no ordinary tearoom.

A seasonal spot, The Bellows set a schedule of opening in mid-June and closing in mid-September. Thekla returned to Long Island with her two daughters for the winter. Upon returning to the Cape for the start of the second season at The Bellows, Hedlund found that business was booming. Whereas in the first season one could show up and find a table, it was now necessary for people to telephone ahead and make reservations. Perhaps it was Sam Cahoon's fresh lobsters, which were part of a $1.50 lobster dinner. It could have been the $.75 dinner specials every night but Sundays and holidays. Whatever it was, The Bellows was a certified hit, and it would only get bigger.

In 1938, Hedlund received permission to expand on The Bellows. John DeMello returned to help build the two additions. Now, when customers entered, they walked into a large reception hall with white pine walls, a beamed ceiling and a large fireplace. The larger dining area was now complete with maple furniture and a spectacular view of a pine tree–lined garden.

The Bellows grew in business and reputation into the 1940s, with Thekla and her two daughters shouldering the load. That wear and tear eventually came to claim Hedlund. In August 1945, nearing the end of her twelfth busy season at The Bellows, Thekla suffered a cerebral hemorrhage. Her daughters immediately closed down to tend to their mother. Despite their best efforts, Thekla would never again open The Bellows. She passed away in April 1946 at the age of seventy-two.

After Thekla Hedlund's death, the building passed through many hands. Charles Colligan bought The Bellows from Hedlund's estate and almost

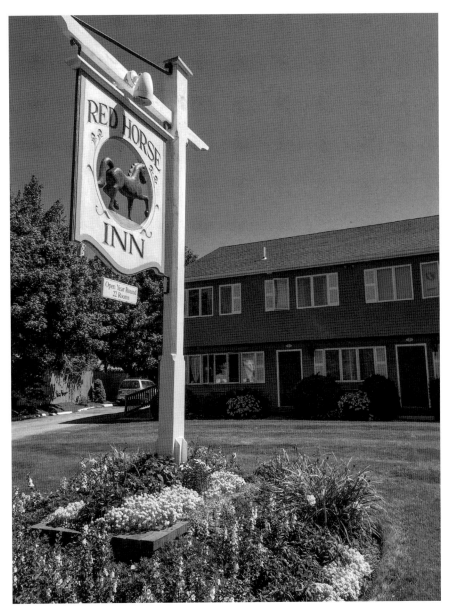

Red Horse Inn, where The Bellows once stood. *Christopher Setterlund.*

immediately sold it to New Hampshire restaurateur William Doukas in 1946. Doukas carried on Thekla's tradition for two more years, even bringing in well-established chefs and bakers from Boston, before selling The Bellows to John Sheehan.

Sheehan turned The Bellows into a guest house and renamed it the Red Horse Inn, likely due to his love of horse racing. In 1952, the Red Horse Inn was sold to Raymond Duffy to be used as a guest house. Grace and Bob Cashman, who bought Red Horse Inn in 1956, worked hard to make it into a landmark in Falmouth. They brought some much-needed stability to the former Bellows and held on to it for forty-seven years. The current owners have been there since 2011, and as of 2016, Red Horse Inn is still thriving.

However, one cannot help but think back to a different time, a different generation. Thekla Hedlund's principles of good food and unwavering quality in cooking and service are the hallmarks of any great restaurant. It is easy to understand why The Bellows was one of the first true iconic establishments on Cape Cod.

BILL AND THELMA'S RESTAURANT

Address: 204 Route 28, West Yarmouth
Years Active: 1951–1979

If you were a teenager in the mid-Cape area from the 1950s to the '70s, chances were that you spent a good amount of time at Bill and Thelma's. If you were an adult in the mid-Cape area from the 1950s to the '70s, chances were that you spent a good amount of time at Bill and Thelma's. In fact, if you lived in the mid-Cape area at all during the two-plus decades that it was open, it is likely that you spent some time at this wildly popular restaurant and hot spot.

Bill Maud began his restaurant venture along the Ocean Street docks in Hyannis in the early 1950s. He ran a small establishment called the Clam Shack that was popular with the locals, travelers and fishermen bringing in their fresh catches. His time in Hyannis was short-lived, as business took off, and there was a need for a new location.

A new home was found in the area of West Yarmouth along Route 28 near the famed Mill Hill Club. The new establishment—still small, roughly diner-sized—needed a new name. Bill incorporated his wife, Thelma, into the equation, and Bill and Thelma's Restaurant was born. Bill was the chef, while Thelma served as hostess. They brought in a dedicated staff, and many stayed as crew for nearly the entire duration of the restaurant's existence. Though not known as the Clam Shack anymore, the new restaurant received rave reviews for its fried clams. So popular were the golden-brown shellfish

that a sign was placed atop the restaurant's roof to alert passersby when they were available.

Bill and Thelma's wowed customers with their fish and chips and onion rings, in addition to the fried clams. They would keep things simple, with items like hamburgers, hot dogs and beans, macaroni and cheese and other fresh comfort foods. The couple also made it a point to position their establishment as a family restaurant, where parents and children alike could come for lunch or dinner and find something they enjoyed for a reasonable price. Bill Maud made the restaurant a hot spot with a ninety-nine-cent dinner. This deal included everything from the entrée to the dessert and became a staple of what made Bill and Thelma's a destination for many years.

The establishment's popularity grew during its run near Mill Hill. The original diner-sized building expanded several times, until it was an impressive setting. It was pure Cape Cod within the walls of Bill and Thelma's, with neutral colors and hardwood adorned by netting filled with seafaring creatures like crabs and starfish hanging from the ceiling. The seemingly cluttered ceiling above contrasted the overall cleanliness of the restaurant; Bill Maud was a stickler for a spotless dining area and kitchen.

Even with the expansion, there were lines out the door of people wanting to get their fill at this spot. If the ninety-nine-cent dinner didn't bring people in, perhaps being serenaded on the organ by Maud himself did it. Bill regularly played the organ, and loyal customers and friends came in, grabbed a cocktail and sang along to some of the standards of the day. Bill loved the organ so much that the local Cape Cod Organ Society held its monthly meetings at his place. During one meeting in 1966, Marie Marcus, Cape Cod's First Lady of Jazz, played piano while John Chapman played the organ. Those meetings were more of a social hour than a serious discussion.

Bill and Thelma's became the place to be as a teenager in the 1950s, '60s and '70s. The restaurant was filled with students from nearby Dennis-Yarmouth Regional High School commiserating in the booths and at the counter after sporting events and dances. Things could get tense if students from rival Barnstable High School showed up, which they sometimes did after defeating Dennis-Yarmouth in a sporting event. However, it was nothing that a frappe and some onion rings could not solve.

Adjacent to the main dining room was the Jolly Tar Lounge, where the adults who came without kids could congregate. It was here that the cocktails were served and various professional sporting events watched on television.

For all of the owners' efforts to make Bill and Thelma's a family restaurant, there was still a desire to have a spot just for the adults. Bill Maud was a people pleaser and a beloved figure in the community. He was known to have once created a skating rink on a neighboring cranberry bog for the children using only his Jeep and a plow. Things like that, the ninety-nine-cent dinners and accommodating many high schoolers in the evenings to keep them out of trouble made Bill and Thelma pillars of the community.

The $0.99 dinners were kept up as long as it was feasibly possible by Bill Maud. Even after that price was untenable, he tried $1.99 dinners for a time. However, as time went on, it was no longer possible to keep those deals up. By then, the business was nearing its end. Business slowed down as the 1970s were nearing the end. Bill Maud would sell his restaurant in 1978 and along with Thelma retire down to Florida, ending nearly three decades in business. Soon thereafter the Italian restaurant Casa Mia would open on the spot. It would not be nearly as successful. As of 2016 Designer Warehouse resides in the building at 204 Route 28.

Even nearly forty years after closing there are many who grew up in the Mid-Cape area who fondly reminisce about their times at Bill and Thelma's.

Bloom's Prime Rib House

Address: 633 Route 28, West Yarmouth
Years Active: 1981–1992

The world of Cape Cod restaurants is tightly intertwined. Numerous successful establishments employed staff who would go on to create their own successful establishments. There has been a lot of cross-pollination when it comes to the restaurant industry on this peninsula. Sometimes an owner—or owners—creates a successful establishment and then goes on to create another or several more. Such is the case of the Bloom family. From the early 1970s through the early 2000s, the Blooms had a huge influence on the restaurant industry of Yarmouth and Hyannis. It began with the highly unique Fred's Turkey House on Route 28 in West Yarmouth, which was run by Fred Bloom in the 1970s. The family's influence would become much greater with the opening of the eponymous Bloom's Prime Rib House.

In May 1981, Fred's son Marty Bloom was presented with an opportunity he could not pass up. Peppino's, an Italian restaurant, had dwelled at 633 Route 28 but was closing. Marty was fresh out of college and took out loans to be able to open Bloom's Prime Rib House. His idea was based on prime rib, a salad bar and creative cocktails. The salad bar concept was made even more unique thanks to a pair of antique bathtubs as part of the motif. Bloom's paid homage to a few different restaurant design ideas, making it both familiar and distinctive.

The opportunity Marty Bloom could not pass up paid off almost immediately. Customers loved the combination of prime rib and a salad bar mixed with the creative cocktails. By the end of the summer of 1981, all the loans Bloom had taken out for his venture had already been paid off.

Not one to rest on his laurels, Marty Bloom decided to change up Bloom's for the second season. He went to a more upscale menu and high-class wine list but held on to the popular prime rib and salad bar combo. The upscale menu included items like steak au poivre and delectable duck and veal dishes. The changes only increased patronage and led to "off the charts" sales for year two, according to Mary. The establishment became a juggernaut, and it convinced Marty that he should stick to the restaurant business and not go back to college for further education.

An eclectic wine list, a varied menu and prime rib—surprisingly none of these things might be what Bloom's is most remembered for. It just might be the lobster bisque.

"We sold three times [as much] lobster bisque as we did clam chowder," Bloom explained, "which is almost unheard of for a Cape Cod restaurant."

Making the highly successful soup was a painstaking process.

"The lobster reduction was made from scratch," Bloom said, "it was time consuming but worth it."

As Bloom's grew, Marty felt it was time to try something new. So, in 1984, he began plans on his next venture in Hyannis. In 1985, Bloom opened Starbuck's, not the coffee chain, but another highly successful and unique establishment located on Route 132. For more on Starbuck's, see chapter 34.

Throughout the 1980s, Bloom's Prime Rib House did well. However, as the 1990s were beginning, America was hit by a bad economic recession. This recession was short, lasting less than a year, but the recovery was also very slow, lasting well into 1992. At first, this did not affect the business at Bloom's. Then, the restaurant's mortgage holder, Bank of Boston, called in its loan. This spelled the end of Bloom's, which closed in 1992.

"That recession," Marty Bloom says, "reset the landscape of Cape Cod. Banks went bust and lots of restaurants closed."

The recession forced Marty to leave the Cape to seek opportunity elsewhere for success. This led him to Brookline, Massachusetts, where in 1993 he opened the first of his Vinny Testa's Italian restaurants. It became a successful chain, and Bloom sold in 2002. He still is an active part of the

restaurant scene, having opened his newest venture, Mission on the Bay, in Swampscott, Massachusetts, in 2016.

As of 2016, the Sons of Erin Cape Cod members-only Irish club stands where Bloom's Prime Rib House once did on Route 28.

THE BONNIE DOONE RESTAURANT

A wee bit of Scotland in Old Provincetown.

Address: 35 Bradford Street, Provincetown
Years Active: 1938–1986

When it comes to the rich and storied history of the Portuguese people in Provincetown, once cannot even begin the conversation without mentioning the Cabral family and the landmark that was the Bonnie Doone Restaurant.

Originally opened in 1937 by Manuel, the patriarch of the Cabral family, and his wife, Mary, this was a seafood restaurant at heart that would go on to specialize in many things. Located on Bradford Street, the Bonnie Doone Grille, as it was first known, delivered native lobsters served many ways, including stuffed, Newburg and Thermidor. Its baked and stuffed extra-large shrimp was a hit, partially because of the secret wine-based stuffing. Swordfish, flounder, crab, scallops—all of the necessary seafood items were present. The Bonnie Doone could have stopped there and likely have been a success, but the Cabrals wanted to go one better.

First off, the Cabrals brought in Joe Pettite to be their head baker. Under his watchful eye and talented mind, Bonnie Doone would become known for its homemade breads, pies and pastries. Next, they brought in renowned Chef Artur from the Publick House Restaurant in Sturbridge, Massachusetts, in 1950 to help them to also specialize in things that didn't come from the sea like steaks, chicken dishes and Portuguese-style pork

The Bonnie Doone Restaurant. *Courtesy of Salvador Vasques.*

chops. Perhaps the most unique aspect of the food prepared by the staff at Bonnie Doone was the fact that the Cabrals had an open invitation for anybody to take a walk into the kitchen and see for themselves how everything was done. Pulling back the curtain gave the restaurant and its customers a more intimate relationship. The Cabrals' dedication to transparency would be rewarded handsomely.

As its popularity skyrocketed, Bonnie Doone began expanding. The Thistle Room arrived in June 1952. This was a new cocktail lounge where one could have a "king-sized" drink and a meal on the second floor of the restaurant. It was complete with sweeping views and a relaxing décor. It would become a perfect spot for private parties, birthdays and even wedding receptions. The man behind the king-sized cocktails, Lenny Backof, was known as one of the best mixologists on the Cape, courting the favor of none other than Elizabeth Taylor during a visit to Provincetown in 1957. His specialty drink was known as the Golden Glow.

In 1958, the Cabrals bought and razed the neighboring Conant Street School. It had been used for the headquarters of the Veterans of Foreign Wars for about twenty-five years. This added much-needed parking for the restaurant, which could then fit up to fifty cars. The little spot that could originally seat 50 in 1937 would eventually be able to serve 350 patrons at a

time. There would be more expansion: the Bonnie Doone Patio for outdoor dining; the long-established Bonnie Doone Terrace, which was another dining room perfect for private parties and intimate dining; and the Bonnie Doone Snack Bar, which allowed the overflow of customers to still get their fill of delicious food even if a table was not available. When all was said and done, the establishment had five dining rooms and two bars.

As the 1960s dawned, the Bonnie Doone was flying high. Open seasonally from mid-June through late October, the restaurant was routinely serving nine hundred to one thousand meals per night, getting close to two thousand at its peak. Accolades—which had been free flowing from loyal local patrons for decades—poured in from national outlets. Duncan Hines recommended the Bonnie Doone, as did AAA. The restaurant was even mentioned as a destination spot on Cape Cod by *Better Homes and Gardens* magazine in 1966.

The Bonnie Doone did not miss a beat when Manuel and Mary retired, and the iconic locale was taken over by their daughter Barbara and her husband, Richard Oppen. The couple, who had married in 1948, successfully carried on the legacy well into the 1980s. In 1986, they retired, effectively putting an end to the nearly five decades of service that the Bonnie Doone had given to the town of Provincetown.

The building lay dormant for several years before being purchased by Crown & Anchor owners William Dougal and Rick Murray and redeveloped into the Mussel Beach Health Club. As of 2016, it is still open and going strong.

CAPE HALF HOUSE RESTAURANT

Address: 21 Route 28, Harwich
Years Active: 1962–1992

I n the late seventeenth century and early eighteenth century, the half Cape Cod house was the starter house for many families with little money. They were one story or a story and a half in size with a shingled exterior. They were common on Cape Cod in its early days of European settlement. It wasn't until a visit from Reverend Timothy Dwight, president of Yale University, in 1800 that the term *Cape Cod house* was coined, and these structures became more a part of New England culture than just Cape Cod culture.

In the twenty-first century, the half Cape Cod house is a historic relic; now centuries old, they dot the landscape of the peninsula as museums or time capsules of a bygone era. However, one of these houses became a landmark on the Cape for an entirely different reason.

In 1737, a half Cape home was built at present-day 21 Route 28 in West Harwich, just before the Dennis town line. More than two centuries later, it would be revived as a restaurant that would add a new chapter to the home's story.

In 1962, the Cape Half House Restaurant was born through the hard work of three people: Gwen Ellis Howes, her son Bob Howes and his partner Milton Chapin. Bob Howes ran Blacksmith Shop Inn in Gloucester and was an associate of Chapin's at the Ritz Carlton in Boston before ultimately coming to the Cape to open the Cape Half House. Gwen moved to the

Cape in 1964 to help her son and his partner in their venture. She ran a small gift shop inside the restaurant.

Within a few years, the restaurant was a big hit, due to the modern fare it provided while maintaining the look and feel of an eighteenth-century home. The restaurant was open year-round and provided many delectable menu choices, such as fresh fish, steak, chops and roast duck. There was even a lunch buffet daily. The daily lunch specials were an attraction all their own, each uniquely named and beloved. Items like "Aunt Boo's Special," "Josiah Clinton," "Izzetta's Summer Fruit Basket" and "Uncle Milt's Stuffed Tomato" were ordered again and again for lunch.

The only thing that could make the food even better was the atmosphere. This was something that Bob, Milton and Gwen worked diligently to capture and maintain. In 1966, a weathered-looking barn was added to the motif of the restaurant property. The garden outside, maintained by Milton, was authentic to the eighteenth-century setup. The original half Cape Cod house began to serve as the reception room and entryway into the restaurant as time passed. The dining room was decorated with colonial-era tools around the fireplace and other artifacts from the home. It was pure colonial New England.

Despite the ever-increasing popularity of the Cape Half House Restaurant, its owners kept the country inn atmosphere and served up amazing menu items like lobster stew, clam chowder, one-pound steaks, the famous Cape Half House Lobster Pie and Milton's special baked Indian pudding served hot with ice cream. The restaurant continued to grow, with the addition of the Parched Patriot Pub next to the main dining room. It was a small lounge with a full cocktail menu.

Business was good throughout the 1970s and '80s; however, the years of work began to wear on Bob, Milton and Gwen. In 1989, all three of them decided it was time to retire from the daily grind. The Cape Half House was leased to Charles Peavey, and the three original owners became landlords. Their retirement was brief. Due to problems with the new manager and a general itch to get back into the business, Bob and Milton returned to the restaurant in 1991.

By then, the writing was on the wall. The Cape Half House Restaurant only survived a few more years before being closed and sold after four decades of serving the public. A few businesses came and went in the years following. First was the Great Wall Chinese restaurant in the mid- to late 1990s. The building itself was sold at auction in 1998. It reopened as Taste of the Orient before changing its name to Noble House. As of 2016, Noble House still resides in the old half Cape Cod house.

Gwen Howes passed away in 2005 at the age of eighty-one, and Milton passed in 2007 at the age of eighty-four. Bob passed in 2012 at the age of seventy-four, bringing an end to the group of people who brought a slice of colonial-era Cape Cod into the twentieth century.

CHRISTINE'S

Address: 581 Route 28, West Dennis
Years Active: 1980–2005

It was a can't-miss spot, both literally and figuratively. Located on the big curve of Route 28 in West Dennis, Christine's set the bar high when it came to entertainment. Some famous names graced the stage in the twenty-five years this landmark was in existence. The three-hundred-seat Christine's packed people in on a nightly basis.

It began in 1980, when Joe Jamiel, straight out of college, purchased the property and originally called it Celebrities. It was a young rock-and-roll bar back when the drinking age on Cape Cod was still eighteen. When the drinking age was raised, Jamiel decided to change with the times. The hopping nightclub atmosphere of Celebrities was replaced with a function room for private parties, banquets and family-style meals. The only thing left was choosing the new name. Jamiel named the venue Christine's after his wife, and the new establishment opened in 1983.

Despite the changes, this spot did not lose its appeal; in fact, it gained even more. The young rock-and-roll bar began incorporating all sorts of musical tastes to increase its audience. Monday was jazz night, and many legendary local musicians played there weekly. Tuesdays were reserved for standup comedy, including a young Jay Leno, who plied his trade on stage there before later becoming host of the *Tonight Show* for many years.

Shows started between 9:00 and 9:30 p.m. and never ceased to amaze and enthrall customers. Jamiel credits having really good agents for helping him book many talented acts. Christine's was seen as the little stepchild of the Melody Tent, a popular music venue that opened in Hyannis in 1950 and is still running strong as of 2016. This was due in part to the fact that several acts would play the Tent and then Christine's, or vice-versa.

It was a family-run restaurant, with Joe Jamiel booking the entertainment, his brother Geoffrey working as the chef and his wife, Christine, running the front of the house. His kids ran and played throughout the restaurant, adding to the true family atmosphere that they wanted to display.

Though it was known for tremendous entertainment, Christine's could hold its own with cuisine as well. It had the classic Cape Cod seafood meals and award-winning clam chowder. It was also known for its buffets on holidays such as Mother's Day, Easter and Thanksgiving. The talented staff could change the function room from buffet setup to nightclub setup in thirty minutes, an impressive feat for a three-hundred-seat establishment.

The entertainment is what made Christine's a landmark. There are legendary stories to attest to that fact.

There was the time that the rock band Steppenwolf came to Christine's. The Canadian American band had some major hit songs, including "Born to Be Wild" and "Magic Carpet Ride," and sold more than twenty-five million albums worldwide. It also attracted a large biker following, and on the night that they played, some two-hundred-plus motorcycles packed the Christine's parking lot to hear the band play.

Sometimes Jamiel got lucky with the timing of the acts he booked, like the time he had R&B singer Chubby Checker come and play in 1988. Not too long after booking him, it was revealed that Checker was to play the halftime show of Super Bowl XXII between the Denver Broncos and Washington Redskins. The publicity for his appearance was off the charts.

Then there were times like when the Guess Who came and played. The Canadian rock band had a string of massive hits in the 1960s, including "No Time," "American Woman" and "These Eyes." After playing a large arena show, the next stop for the band was Christine's. The band walked into the three-hundred-seat function room thinking it was just a place where they were going to eat and asked where the venue was, not knowing they were there already.

Perhaps the most famous story is that of the time the band War played. The California-based funk rock band had some substantial hits, including "Low Rider" in 1975. However, when the band was nearing the end of its

show at Christine's, the musicians played another hit—"Why Can't We Be Friends?" It was during this song about peace, love and friendship that a massive brawl erupted between patrons right in front of the stage, completely contradicting the message of the song.

There was also the time that Boston Red Sox first baseman Mo Vaughn came to help promote the Dream Day on Cape Cod charitable event. He had just been named American League Most Valuable Player in 1995. Again, the hype for this appearance was palpable, and it included legendary Boston sportscaster Bob Lobel coming down to interview Vaughn from Christine's.

Not to be forgotten in the world of Christine's entertainment was the Italian wedding show dinner theater and music from the reggae, folk and even disco genres. It was true that this spot had something for everyone.

As the twenty-first century dawned, it started becoming harder to book acts due to the rise of local casinos. Jamiel said that felt he was "starting to get a little old for the nightclub scene." It was around this time that he opened the first Ardeo Mediterranean Grill on Station Avenue in South Yarmouth. At one point, there were five of these spots featuring Mediterranean cuisine. For a few years, the Jamiel family ran both Ardeo and Christine's, but the rapid success of Ardeo—combined with the tragic loss of Joe's brother Geoffrey in 2006—made it easier to sell the legendary establishment.

It has been over a decade since Christine's lights went out for the last time, and people still reminisce about it. After sitting dormant for many years, in 2015, a new complex opened on that famous curve in West Dennis, anchored by a barbecue restaurant called Billygoats.

As of 2016, Joe Jamiel still runs the one remaining Ardeo, located on Route 6A in Brewster.

CHRISTOPHER RYDER HOUSE RESTAURANT

Address: 1144 Route 28, Chatham
Years Active: 1953–1983

History, beauty, charm and delicious food were only a few of the elements that could be used to describe this Chatham landmark. The Christopher Ryder House was originally built in 1818 on what is now the corner of Route 28 and Crows Pond Road. It remained a part of the Ryder family until 1943. In the years before it became a restaurant, it was a post office and general store.

In 1953, the Kastner family, Donald and Louise, purchased the home and had it carefully lifted and turned ninety degrees. This was done so that any cars traveling north on Route 28 would be face to face with the beautiful façade of the house and not its side.

When it first opened, the house turned restaurant seated 110 people. In 1962, the owners opened an opera house, which helped many professional singers and actors get a start. Two different shows per night were offered at the opera house, making it a must to visit the restaurant often. So popular was the opera house that a vinyl jazz LP record was recorded there in the mid-1960s featuring such artists as Anthony Rando, Theodore Russo, Thomas Christie, John Salerno, George Perrone and Kathleen Rubbicco. Today, the album is a rarity and a major collector's item for anyone who enjoys jazz or has fond memories of the Christopher Ryder House.

As the 1960s drew to a close, the Kastners added the Pavilion Room to the restaurant. This was completed in 1968 and increased the capacity of

the building to 450 people. Around this time, the beloved singing waiters and waitresses were brought in to add to the unique atmosphere. When it reached its zenith, there were also three cocktail lounges to go with the opera house and an orchestra that offered post-dinner dancing.

Former Ryder House waitress Nicole Muller, who went on to become a reporter for the *Register* in Dennis, remembers her time there fondly:

> *It was very upscale and proper....There was a free raw bar, and formal dress was required. There was a closet filled with men's sports coats and ties for those who were first timers and didn't know better. Women wore long dresses/cocktail dresses. The cocktail lounge tables all had crocks of port wine cheddar and baskets of Ritz crackers. One of the lounges featured a piano bar. Roy MacArthur, who wrote and directed the Broadway musicals in the opera house, often played the piano earlier in the evening. Obviously, reservations were highly recommended.*

MacArthur wrote and produced four shows for the opera house each summer, and he hired actors and actresses from New York City to come and perform them. The Kastners allowed MacArthur and his cast to stay locally in homes they owned. The Kastners also provided housing for busboys and setup girls who came over to America from Ireland.

The upscale class of the Christopher Ryder House Restaurant extended throughout the staff thanks to Donald Kastner's desire to only hire the most qualified employees. Since he was an Ivy League graduate from Cornell University, he made it a point to hire managers each summer who were also involved in the hotel and restaurant management program at Cornell. He also only hired wait staff from the best colleges. Nicole Muller remembers people being brought in from schools like Smith College in Northampton, Massachusetts; Wellesley College; and Vassar College in Poughkeepsie, New York. Muller graduated from Brown University.

Kastner's keen eye for talent extended to the training program for the employees. All were required to arrive two weeks early to train and learn how to serve flawlessly. If employees could not provide this service to Donald and Louise Kastner in training, they were sent home, as they only wanted to provide the absolute best for their customers.

Christopher Ryder House served only dinner, and the tremendous kitchen crew helped make each night a special occasion for those in attendance. The seven dining rooms were always packed with people waiting patiently for their slice of decadence. When you were called to your table, a fine crudités tray

The Christopher Ryder House as it looks today. *Christopher Setterlund.*

was immediately served, complete with imported olives, marinated peppers and more. Chef Dick Shea poured out specialty after specialty. The veal cordon bleu, chateaubriand for two and paella were unrivaled. After dinner, customers could order desserts from a rolling cart that was brought directly to the tables to help one make an admittedly difficult choice. However, items like the homemade Napoleons were very popular.

The attention to detail and desire to provide great food and a classy atmosphere are the things that the Kastners wanted and achieved at the Christopher Ryder House Restaurant. The family sold the business in 1983, and in time, the historic home became the centerpiece of a cluster of condominiums. As of 2016, the domiciles still stand and are going strong.

The Cleaver Restaurant and Lounge

Address: 24 Route 28, Orleans
Years Active: 1974–1995

In recent years, ideas like organic, farm-to-table and supreme freshness are qualities that many restaurants are featuring and showcasing to attract new customers. But this idea is not new; there have been several Cape establishments over the years that have specialized in this same ideal. One such example is the Cleaver Restaurant in Orleans. Four decades ago, this spot overlooking Town Cove was building a reputation based on those qualities.

In 1974, the Cleaver opened in a space that had been a furniture store, the brainchild of Gary Kaser and Gaston Norgeot. Norgeot had previously been an Orleans selectman from 1963 to 1972 and would be reelected in 1975–84. He had also managed the Eastward Ho Country Club in Chatham from 1964 to 1974. Gary Kaser was first in his high school class, graduated with honors in college and served as the head of his platoon in the army. He parlayed that education into a job teaching history at Bourne High School and Otis Air Force Base Middle School in the 1960s.

Together, the two created a unique and welcoming establishment that would delight patrons for two decades. The warm and intimate dining area with its dark wood paneling and candlelit tables set the scene for the wondrous dishes that were prepared with care. The quality of the menu and attention to detail became the legacy of the Cleaver.

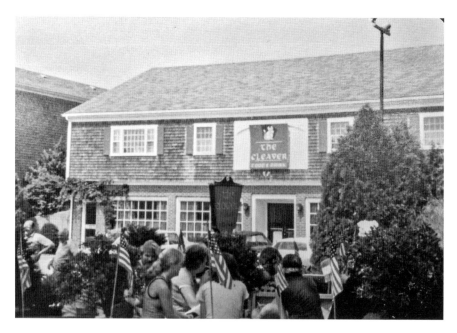

Outside the Cleaver in Orleans. *Courtesy of William Kaser.*

With a focus on steaks and seafood, the Cleaver showcased the fresh meats on an open grill that customers could see. They could watch the cooks preparing their steaks or choice seafood like swordfish right there on the grill. Of course, in addition to steaks, the Cleaver featured favorites like prime rib, roast lamb and chicken made in either of the two kitchens. There were also unique specialties, such quahog pie and a French cassoulet dish with shrimp and scallops.

The key above all else was the freshness. Kaser and Norgeot made it a point to purchase their fish from local spots like Nauset Fish and Lobster. Their breads and pastries were made daily on the premises, salad greens were freshly grown locally in season and even their Caesar salad dressing included fresh eggs. Everything was made from scratch, mostly by Kaser, from soups and salad dressings to desserts. Those who ate at the Cleaver knew that they were getting a meal that was not only delicious and satisfying but also made especially for them.

Gaston Norgeot left the Cleaver in 1979, but the establishment remained in the capable hands of Gary Kaser and his three sons. Kaser and his staff worked hard to make sure that each customer had a great experience dining with them. Because of this dedication, there was a steady stream of regulars

that visited. The bar crowd comprised all well-known locals who enjoyed a few laughs with bartenders Bob Haskell and Ray Squire. There was also the talented, albeit blind, piano player Jim and his ever-present seeing-eye dog, Moon. It was a homey local hangout for some and an intimate dining experience for others.

The Cleaver added Sunday brunch and daily lunch specials to keep things new and exciting. One could come in and get escargot and vichyssoise as appetizers and follow it up with a steak and a baked potato and never have the quality waver one bit. That was the dedication that Gary Kaser gave to his clientele. Kaser hosted political fundraisers, including one attended by Senator Ted Kennedy. Kennedy asked Kaser's son William, who was four years old at the time, to become a Democrat. The young boy replied that he was going to become a farmer.

Kaser routinely gave back to the community and held dinners for the local fire and police. Extra dinners from parties were often dropped off to the Orleans Police as a gesture of thanks. There was even an outdoor clambake held in the parking lot for the Marine Drum and Bugle Corps Silent Drill Team.

The popularity of the Cleaver led Kaser to double the size of the upstairs lounge in 1990. He continued his dedication and hard work for a few more years, until the time came to sell the restaurant in 1995. Gaston Norgeot briefly managed Eastward Ho again after losing his selectman's seat in 1984. He passed away in 1991. Gary Kaser spent his time after the Cleaver fishing, gardening and still enjoying to cook. He passed away in 2001, leaving behind a legacy of more than great food and a popular establishment. His was a legacy of giving back to the community he loved.

As of 2016, Gladstone Furniture stands where the Cleaver Restaurant did for more than twenty years.

THE COLUMNS

Address: 401 Route 28, Dennis
Years Active: 1962–1986

Elegant, beautiful, mysterious and charming—these words all describe the historic Greek Revival house situated at 401 Route 28 in West Dennis. The history of this structure is a tale of three chapters. For many of the younger generation on Cape Cod, this white building and its decaying façade and unkempt landscape is an eyesore, something that could be seen as a place where scary movies take place. It is a place to be observed from far away with a wary eye.

For generations long since gone, this house was something completely different. It was the stately home of Captain Obed L. Baker. Born in 1817, Captain Baker went to sea at an early age and was a ship captain by the age of twenty. His legacy on the ocean is undeniable. At the age of thirty-two, Baker became a master mariner, a highly regarded term used since the thirteenth century in England and its territories. The phrase indicated someone was a master of their craft, in this case, seamanship. Baker commanded a three-masted schooner named *Luther Child*. Owned by the Philadelphia Steamship Line, it was the first American ship to visit Malta Harbor off the coast of Italy.

In 1862, Captain Baker built the home on fifteen acres of property. The five-thousand-plus-square-foot home was known as Elmgate. Inside, it was complete with marble fireplace mantels, French chandeliers, an elegant

carved wooden staircase banister that led to the second floor, delightfully colored carpeting, damask draperies and Brussels lace curtains. Outside, it showcased a gable roof and, most striking of all, a half-round portico of columns that had been shipped down from Boston in freight cars.

In 1892, Elmgate hosted the marriage of Captain Baker's daughter Rebecca May. The captain passed away in 1895. Rebecca added glass wings to the house just after the turn of the twentieth century, and she lived in the house until her death in 1957. The property was sold several years later, and the stylish residential home was transformed into something completely different.

The middle chapter of the home at 401 Route 28 is the most well known of the three. It began in 1961 when Stewart Wallen, formerly of Wellesley, Massachusetts, purchased the Elmgate property, which had been owned by the Baker family for nearly a century. Wallen, who had previously run the Four Seasons Restaurant in New York City, christened the home the Columns and reopened it as a restaurant in the summer of 1962. Most of the artifacts and furnishings of the Baker family home were preserved by Wallen in a museum at the new restaurant, as he tried to stay faithful to those who had preceded him. The Columns served dinner in the elegant first-floor dining area and alerted people passing by on Route 28 with a sign that read "Serving the Evening Meal."

Wallen sold the Columns in 1971 to jazz aficionado Warren Maddow. This transaction would take the restaurant into a whole new stratosphere of popularity. He and his wife, Byrle, had a connection to and love of jazz music that turned the Columns into a swinging jazz club. He hired Marie Marcus to be music director of his new enterprise. Marcus was known as Cape Cod's First Lady of Jazz and appeared on the original *Tonight Show* with Steve Allen in the 1950s. She played at another legendary establishment, Mildred's Chowder House in Hyannis, in 1963 for a short time with Jim Blackmore, whom she had met during a show at the Coonamessett Club in Falmouth.

Marcus's star power led to many well-established jazz artists coming to play shows at the Columns. Names like pianists Dave McKenna, Earl "Fatha" Hines and Teddy Wilson, saxophonist Scott Hamilton and trumpeter Lou Colombo all performed on the ballroom floor at one point or another. From 1971 until 1976, the Columns was the place to be for great jazz on Cape Cod. It was even home to an annual jazz festival during that time.

However, the restaurant/nightclub could not seat that many people, even after an outdoor tent and deck section had been added. That, coupled with patrons frowning on a small entertainment fee, meant

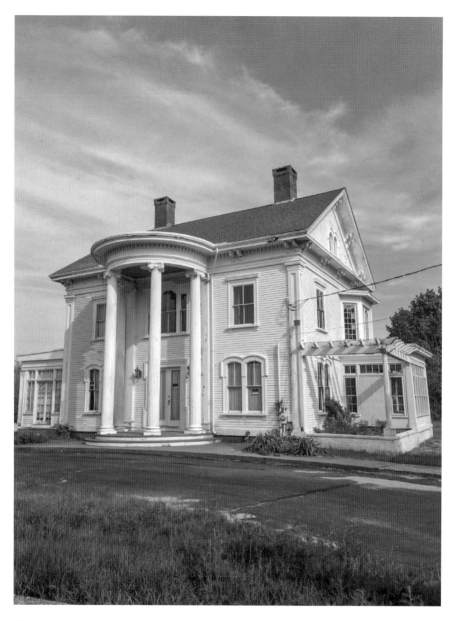

The Columns in Dennis as it appears today. *Christopher Setterlund.*

that there was not enough money being made from the jazz shows to pay for such great entertainers. It would be the beginning of the end for the Columns.

Byrle Maddow sold the Columns to jazz bassist and Boston native Roy Ormsby in 1979 when Warren died after a long battle with lymphoma. Ormsby ran the establishment for a few years before it was sold at auction in 1986. Despite extensive restorations in the years since the sale, the lights have remained off at the Columns. Several people and groups have come in with high hopes of opening something new inside the 150-year-old former sea captain's home, but as of 2016, the home remains stoically quiet as thousands of cars pass by it daily on Route 28.

THE CRANBERRY GOOSE/MOOSE

Address: 43 Route 6A, Yarmouth Port
Years Active: 1950–1992

R oute 6A runs along the north side of Cape Cod from Sandwich through Orleans and again for a bit in Provincetown. The road is known for traveling through the quaint tree-lined villages of the Cape. It is dotted with historic homes and some fabulous restaurants. In Yarmouth Port, this is particularly evident. The historic sea captains' homes, shops and restaurants are part of what gives this village its charm. One such restaurant gave visitors and locals alike all of the scenic views and delicious food they could hope for in its forty years in service. This eatery would be known by two names: Cranberry Goose and, later, Cranberry Moose.

The Cranberry Goose opened in 1950 on a curve at 43 Route 6A in Yarmouth Port. Setting up shop in a historic home, the restaurant began under the ownership of Dorothea and Castenzio Fiorenza. The couple summered on Cape Cod for years while living in New York City. Eventually, the call of the Cape was too much, and they decided to make it their home.

The historic home turned restaurant was an immediate hit with its interior of cranberry-colored walls, subtle lighting and rustic country cooking. The exterior was also cranberry-colored, with the side of the building draped in a trumpet vine. The driveway and parking lot was made up of pea stone, allowing each vehicle to softly crunch its way onto the property. The restaurant was shaded by trees and the air in the parking lot filled with the

aromas of what was being prepared just on the other side of the kitchen walls. Customers at Cranberry Goose were enthralled before even entering the establishment.

The Fiorenzas retained ownership of the Goose for thirty years. The seasonal restaurant maintained a high level of quality, relying on freshness and creativity. This creativity was validated when Castenzio penned a cookbook in 1966 called *Of Passion and Fiddlesticks*. This book featured many recipes Cranberry Goose was known for at that time and today serves as a time capsule of how the restaurant was run in its first two decades.

Cranberry Goose gained a measure of notoriety when it hired Reverse Freedom Rider David Harris in 1962. Harris, from Little Rock, Arkansas, came to the Cape on a one-way bus ticket financed by the Segregationist Capital Citizens Council. These "reverse freedom rides" were a hoax perpetrated by southern segregationists trying to rid the South of African Americans with false promises of high-paying jobs waiting for them in cities like Chicago, Cleveland and New York. Sadly, most of those sent north did not find good jobs. The Fiorenzas were one of the few to take a chance and hired David Harris to work in their kitchen.

Dorothea and Castenzio sold their beloved Cranberry Goose in 1980. It was at this point that it would begin an equally impressive second chapter.

The Goose was purchased by Tom Rolland and Jerry Finegold, who would come to be known as "Tom and Jerry." Their first order of business in making the establishment their own was to change the name from Cranberry Goose to Cranberry Moose. "The Moose," as it would be affectionately known, gained a measure of acclaim when it commissioned famed writer and illustrator Edward Gorey to create the design of the restaurant's new menu.

Gorey had gained notoriety from the 1950s through the 1970s in New York City. In 1979, he purchased a home not far from the restaurant on Strawberry Lane; it would go on to become a museum dedicated to his life and work after his death in 2000. In 1980, Gorey illustrated the opening credits to the PBS show *Mystery!*, hosted by Vincent Price. The menu, which featured a Moose waiter in the classic Gorey Victorian style, gave the Cranberry Moose a new level of cachet.

The new owners prided themselves on the landscape of the exterior and interior design of the establishment. Ed Woelfle, who was the executive chef at Cranberry Moose from 1983 to 1987, remembers their motto being "Flowers, Food, and Friends." The beautiful floral arrangements were lovingly cared for by gardener Joe Crafey, but they were only part of

the charm of the Moose. Tom and Jerry were gracious hosts, making each customer feel warmly welcome to the point that several of them had standing reservations for every Friday and Saturday night throughout the summers.

The menu was simple but exquisite. It began with sourdough bread freshly baked by Katie Tobey. Woelfle prepared such favorites as roast duck, rack of lamb and filet of beef with Rhode Island red wine from the Sakonnet Vineyard in Little Compton, Rhode Island. These dishes would all be garnished with herbs from the garden outside. Dessert was legendary. One could partake in either the cranberry-apple mousse or the amazing cheesecake. These were homemade by Martha Scharffe. She and her husband, Walter, used to own the Cummaquid Inn, located at 2 Route 6A in Yarmouth Port. As of 2016, it is known as Anthony's Cummaquid Inn. Chef Woelfle remains grateful to this day that Scharffe gave him her cheesecake recipe, as he still has people coming to him to this day remarking on it being the best they had ever had.

Dinner in the three dining rooms was spectacular thanks to the complete effort of the staff and owners. The Yarmouth Port Room was smallest and sat about twelve people; the Tulip Room was white and had pencil drawings of tulips on the walls; and the Gallery featured local art, due to the fact that Tom Rolland was an artist himself. The décor in that dining room was constantly changing.

In 1988, Tom and Jerry sold the Cranberry Moose to Marietta Bombardieri, who had previously owned the spectacular Neptune Room in the Barnstable Airport as well as La Cipolina on Route 6A in Yarmouth Port. Bombardieri kept the Moose running for a few more years, adding touches like live music, a prix fixe menu during the fall and a Mediterranean touch on the menu. In 1992, she changed the name of the restaurant to Abbicci, and the cranberry façade became golden. The restaurant would remain unchanged until 2008, when it became known as Lyric. As of 2016, the historic building at 43 Route 6A in Yarmouth Port is occupied by Primavera Ristorante.

DANNY-KAY'S ITALIAN RESTAURANT

Address: 145 Route 28, East Falmouth
Years Active: 1959–1977

Danny-Kay's is the story of an immigrant Italian family who set up shop in Chicago and would go on to own the "undisputed headquarters for Italian food" in Falmouth. For four generations, the Bartolomei family has been wowing customers in Massachusetts with their authentic cuisine. Before becoming beloved restaurateurs in Falmouth, the family had to make their way to America.

In 1914, the patriarch of the family, Giorgio Bartolomei, left his home in Peigaio, Provincia Di Lucca, Italy. His plans to establish himself before sending for his family were changed when an influenza outbreak took the life of his mother-in-law, aunt, daughter and youngest son the next year. In 1918, his wife, Rosina, and son Daniel came to America to join him. They initially settled in Chicago but left for Worcester after only six months.

The family's first venture into the restaurant business occurred in 1938, when Giorgio, Rosina and Daniel shared their home recipes in a place called Danny's Spaghetti Shop. Located on Grafton Street, it was an introduction to the delicious foods the Bartolomei family would thrill customers with for the following four decades. The family first ventured across the Cape Cod Canal in 1949, when Daniel moved there with his wife, Carmela, and their five children. The first Danny's Pizzeria opened on Main Street in Buzzards Bay. In 1958, the pizzeria moved south to Falmouth, where it again resided

on Main Street. However, there would only be a year of Danny's Pizzeria before a new establishment came to fruition.

In 1959, Daniel and Carmela moved their business a few blocks away to 145 Route 28. The pizzeria concept retired, and Danny-Kay's Italian Restaurant emerged. The restaurant still showcased their signature oval-shaped pizzas, but this would be only part of their menu. The authentic Italian cuisine, featuring favorites like spaghetti and meatballs, lasagna, stuffed shells and various parmesans—coupled with the already well-known pizza—made the new restaurant an instant hit in Falmouth. Carmela baked the bread for the restaurant herself.

The popularity of Danny-Kay's was the payoff of a calculated risk undertaken by Daniel and Carmela, who had traded their home for the chance to take over the building at 145 Route 28. If the restaurant had failed, they and their five children could very well have ended up out on the streets. Instead, Danny-Kay's flourished, and the Bartolomei family lived upstairs above the restaurant.

Danny-Kay's was a smash hit throughout the 1960s and into the 1970s. The basement of the building was redone to allow for private gatherings and bigger parties to be served away from the crowded dining room on the first floor. The establishment became a weekly dining experience for many families, with many local children growing up right along with the restaurant. During the tourist season, Danny-Kay's was always packed to the gills with people patiently waiting for their chance to enjoy the delicious food within. It became a hangout for locals and the place to get great Italian food in a time when it was not as widely available as today.

Throughout the off season, Danny-Kay's opened only Thursday through Sunday. To keep himself busy during the down time, Daniel worked at places like the LaSalette Seminary in Brewster, which later became Ocean Edge Resort & Golf Club. He occupied himself by working on boats in the barn that stood behind the restaurant. By 1977, both Daniel and Carmela had grown weary of the daily grind of running a highly successful restaurant. They sold Danny-Kay's and retired to a home along the Coonamesset River in Falmouth.

The restaurant was replaced by Golden Sails, a Chinese restaurant, which as of 2016 still stands at the spot. Daniel and Carmela passed away within two months of each other in 2006. Their grandson Jay Bartolomei, owner of Villaggio Ristorante in Cotuit, immortalizes Daniel and Carmela by combining their two marinara sauce recipes into one in a show of respect to the former owners of the "undisputed headquarters for Italian food" in Falmouth.

THE DOME RESTAURANT

Address: 533 Woods Hole Road, Woods Hole
Years Active: 1954–2002

Buildings come in all shapes and sizes. There are countless uniquely designed structures all over Cape Cod. Simply taking a drive down Route 6A can open up a world of wonder and amazement at some of the newer and historic homes that don't fit the normal mold.

The same can be said for restaurants. Not all are built the same. In fact, in Orleans, the Hunan Gourmet III Chinese Restaurant is actually built into the side of a hill. However, any uniquely designed restaurant on Cape Cod, current or past, must take a backseat to the Dome Restaurant, which resided in the small scientific community of Woods Hole.

This one-of-a-kind establishment existed inside an actual geodesic dome.

A geodesic dome is sphere-like in shape and consists of a thin skin with a network of triangles as a frame evenly distributing stress on the dome. Spaceship Earth at the EPCOT Center at Walt Disney World in Orlando, Florida, is one of the most famous geodesic domes on earth.

The idea of the geodesic dome was the brainchild of architect R. Buckminster Fuller. Born in Milton, Massachusetts, in 1895, Fuller developed the geodesic dome while in the navy during World War II. He saw it as a potential solution to a world housing shortage and received a patent for his geodesic dome in 1954. Fuller put his money where his mouth was by having a geodesic home built for himself and

Inside the Dome Restaurant. *Courtesy of Falmouth Historical Society.*

his wife, Anne, in 1960 in Carbondale, Illinois. That home still stands as of 2016.

So how did a geodesic dome come to be a popular and perhaps the most intriguing restaurant ever built on Cape Cod? It was actually part of a larger project known as the Nautilus Motor Inn. The dome, called Club Dome, was simply part of the package.

The fifty-four-room Nautilus Motor Inn was designed by Falmouth resident and MIT-educated architect E. Gunnar Peterson in 1954. R. Buckminster Fuller oversaw the construction of the geodesic dome, which ended up being fifty-four feet in diameter and twenty-seven feet tall. The first free-standing dome of its kind would also prove to become another first. It would be the first geodesic dome restaurant.

Elegant décor was combined with spectacular views of nearby Little Harbor to make the Dome a unique place to dine. Many special occasions were held in this setting, including weddings, and it only made the moments more magical. The upscale 170-seat restaurant was more than just a novelty—it was a hit throughout the 1950s and '60s. The views were matched by specialty sandwiches on the Dome's menu: "Nobska Turkey Special" (with bacon, swiss cheese and Russian dressing on a bulkie roll) and the "Nautilus Roast Beef" (with sliced onions and

Russian dressing on a bulkie roll). The Dome also served breakfast and specialized in locally caught seafood.

Unfortunately, over time, the owners of the restaurants noticed that the construction of the dome was causing problems. Its glass enclosure caused the interior of the restaurant to heat up much like a greenhouse thanks to the sun overhead, and it also had problems with water leakage. To remedy this, fiberglass was laid over much of the dome, obscuring the majestic harbor views that patrons loved.

For decades, the Dome was a must-see attraction almost on par with the nearby Woods Hole Oceanographic Institute. It closed in 2002 and in the time since has fallen into disrepair. There have been plans to restore the geodesic dome and make it a historical attraction for visitors from as far back as 2008. The closed Nautilus Motor Inn was to be torn down as part of the plans. As of 2016, the restoration had not occurred, and the dome still sits unoccupied atop of the hill.

DORSIE'S STEAK HOUSE

Cape Cod's most complete dining and entertainment complex

Address: 325 Route 28, West Yarmouth
Years Active: 1974–1990

This legendary establishment along the high-traffic Route 28 in Yarmouth had a dedication to great entertainment and terrific food. Its status as a place to be was in part thanks to the tireless efforts of its larger-than-life owner. For nearly two decades, George "Dorsie" Carey ran his eponymous steak house in two separate locations along Route 28, creating buzz around town with his entertainment and cuisine.

Carey had come to the Cape from Dorchester. And no, this was not how he got the nickname Dorsie. That nickname was bestowed on him by his niece while they were living in the same three-story building in the historic Boston neighborhood. She could not pronounce the name George, and as it usually came out "Dorsie," the name stuck with him. Carey had another nickname that became the name of a restaurant—"Handlebar Harry"—due to his handlebar moustache. He opened Handlebar Harry's in Plymouth with his wife, Louise Houston, in 1991.

Dorsie's began as a much smaller restaurant located at 183 Route 28 in West Yarmouth, near the iconic Mill Hill Club in 1974. Business took off over the next few years. The landlord of the property decided after the 1978 season to increase the rent for the property 400 percent, from $8,500 per

Before it was Dorsie's, it was the Gay Nineties. *Courtesy of Louise Houston and George Carey.*

month to $35,000. This shocking increase set off a chain reaction that ended up taking Dorsie's to new heights.

Carey searched all along Route 28, from Hyannis to Bass River, in the hopes of finding a new location. One of his regular customers at the restaurant was, in fact, owner of an establishment called the Gay Nineties located half a mile away on Route 28. After hearing of Carey's plight, the owner sold the Gay Nineties building to him on a handshake. On the night of July 3, 1979, Carey, his staff, close friends and some of the Yarmouth Police worked through the night and moved all of the equipment from the original Dorsie's down the street and into its new home.

"We were opened July Fourth," Carey proudly reflected, "although there was no food service until July Fifth."

That hard work of finding the new location paid off.

The new, larger Dorsie's had a lot more space for patrons and entertainment. There were three unique function rooms at this location. There was the Cranberry Room, which was located over the main dining room. It was totally self-contained and seated 60 people. There was the Nineties Room, which had an 1890s motif as a nod to the former Gay Nineties Restaurant. This sat 200 people. Finally, there was the Waterwheel Room, which was the primary function room. It sat an impressive 350 people and was complete with its own banquet kitchen.

There was always something going on as far as entertainment went at Dorsie's, including an up-and-coming Jay Leno plying his trade in the Waterwheel Room. Leno had been contracted to play another legendary establishment in West Dennis called the Golden Anchor. However, that place was sold before he could perform, so Leno's contract was given to Dorsie's. He was given the gate while the restaurant kept what the bar brought in.

Diane Dexter, who played piano and sang at Dorsie's starting in 1981, has fond memories of her time playing there as well as the man behind it all.

"I worked in their main lounge on a grand piano as a solo act," she recalled, "playing and singing standards and pop/folk/country/rock songs that were popular at the time."

Dexter also recalls the Dorsieland Ragtime Review, a Dixieland band that played in the Gay Nineties Room and was a very popular attraction. As for Carey himself, Dexter remembered that he was "always very good with people."

The one thing that put Dorsie's over the top was its affordably priced food. The establishment did a tremendous liquor business, which Carey wisely reinvested in his menu. Marinated steak tips, steak teriyaki and prime rib were the biggest sellers, made even better by the fact that the meat would be cut and cooked at the Pit, right out in the dining room. Customers could watch while their food was prepared before their eyes. It only added to the uniqueness of Dorsie's.

After years of successfully running his mid-Cape complex, Carey yearned for a change. He got that chance when Cordage Park in Plymouth, which converted buildings into a mall in the 1980s, came calling. Carey sold Dorsie's in 1990, and it became a Lambert's Farm Market. In 1991, Carey opened Handlebar Harry's, which became the anchor of the mall. It was tremendously popular in its own right and ran until 2003.

Today, George "Dorsie" Carey is retired, but even more than twenty-five years after Dorsie's closed its doors, he still has people coming up to him and wanting to reminisce about those good old days. As of 2016, Antiques Center of Yarmouth stands where Dorsie's once did.

EAST BAY LODGE

Address: 199 East Bay Road, Osterville
Years Active: 1886–1998

Longevity breeds respect. It also creates memories spanning across several generations. There are few places on Cape Cod that have created as many memories across so many generations as the East Bay Lodge. How could there be? This icon of Cape Cod ruled the restaurant and hotel industries for a century. It housed weddings, banquets, private functions and birthdays while also giving visitors a place to rest their heads in between sunny days of exploring the Cape.

The legacy of East Bay Lodge goes all the way back to the latter part of the nineteenth century. The lodge was built by Nelson H. Bearse Jr. in 1886. Bearse had gone to sea at age twenty-two, captaining a schooner named *Nelson Harvey*. Nelson and his wife Mary's home, which overlooked peaceful East Bay and Nantucket Sound, became a popular inn. From its beginnings, the village of Osterville was a prime resort area and attracted people from all over. It was only natural that the Bearses accommodate visitors. In 1890, an extensive remodeling job transformed the Bearses' house from a good-sized family home into the glorious inn that would become one of the finest in all of New England. Another expansion would occur in 1900, when the neighboring Josiah Ames Homestead was turned sideways and incorporated into the lodge. In 1911, another annex was constructed to house the growing staff.

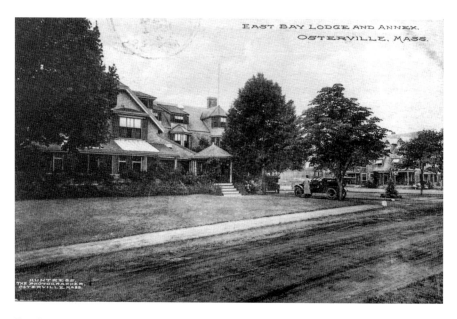

East Bay Lodge. *Courtesy of Sturgis Library.*

The twentieth century dawned, and the popularity of East Bay Lodge only grew. It became the place to be and to be seen for vacationers, rivaling any other inn or resort along the East Coast. Once it opened for the season, the arrivals at the lodge would be posted throughout the local newspapers. Guests could walk the beautiful grounds, traverse through the flower gardens, find a cozy nook to relax in the shade of a tree or simply stare off at boats passing by and breathe in the salty air. For fun, there was golf, tennis, croquet, fishing, boating and swimming to be had. East Bay grew into an estate with time, boasting multiple buildings and seventy-five rooms. It was meant to be a home away from home, with guests rarely staying for one night but more often weeks or months. However, not all of those who wished to stay there had the means to do so—for those there was another side to East Bay Lodge.

The elegant resort was home to some of the most exquisite fine dining Cape Cod had to offer. From the décor to the cuisine, East Bay Lodge took on a whole new life for those who came to dine there. The interior of the dining room was dotted with beautiful oriental rugs over hardwood floors. Each table was adorned with white tablecloths, fine china and silver. It was a feast for the eyes before the food was even thought of. Fine dining meant formal dress; men were required to wear jackets, while women needed to be in a dress or formal pantsuit.

Though it would change over time, the menu always catered to the finest tastes. Swordfish, cod, scallops, lamb, prime rib, filet mignon and a wide array of wines were available for guests of the hotel and those who came simply to enjoy an elegant dinner. One could even find unique delicacies like shad roe and frog legs on the menu at times. Vegetables from the garden outside were used to make some of these sumptuous meals.

When the Bearses retired and moved to Providence in 1917, East Bay was taken over by Charles Brown and Forrest Toward. At one point, Brown was president of the Cape Cod, Martha's Vineyard and Nantucket Hotel Association. There would be some close calls with disaster, like the fire in May 1923, which luckily was contained with very minimal damage. In 1924, Brown became sole owner. He continued to make the Lodge a place to be for more than twenty-five years until his retirement in 1943. It was then purchased by F.L. Putnam.

East Bay Lodge stood tall among the giants of the hospitality industry of the early twentieth century like the Chequessett Inn in Wellfleet and Wianno Club in Osterville. Its popularity facilitated year-round business, and it became a hot spot for banquets, weddings, private parties and holiday gatherings. Bob and Janel Kesten moved to Osterville and took over East Bay in 1965, promoting the dining side to the inn as much as the hotel. There was entertainment and dancing nightly to add a little more flare to the well-established lodge. The Kestens also promoted catering, to help bring the East Bay experience to places beyond the grounds. Shellfish buffets, fabulous roast beef, Sunday brunch and a constant finger on the pulse of yesteryear kept this spot pumping out satisfied guests and customers as it reached its 100th year. Francis Ricci joined the ownership team a few years after the Kestens. They stayed aboard even as the famed lodge again changed hands in 1984 after being sold to Basil Ente.

Sadly, all good things come to an end, and such was the case with East Bay Lodge. After serving and delighting innumerable guests over a century, the restaurant was shuttered in 1996. It was run as an inn by Jim Crocker for two more years before it closed and was demolished in 1998. The East Bay Lodge was replaced by Cove at East Bay, a selection of fifteen luxury townhouses, which still stands as of 2016.

To this day, people still wistfully think back to past visits to East Bay. They remember each trip there as a special occasion whether they were celebrating a special occasion or not. The longevity of East Bay Lodge not only bred respect and created memories, but it also made it one of the most beloved spots on the Cape for countless guests.

ELSIE'S

Address: 553 Palmer Avenue, Falmouth
Years Active: 1966–1986

Falmouth via Cambridge and Nuremberg, Germany—this is the journey of the people behind Elsie's, a landmark of Palmer Avenue for two decades. Many Cape Cod restaurants have interesting or inspiring stories behind their creation. Few have stories more deeply entrenched in world history than the story behind Elsie's and its owners, Elsie and Henry Baumann. Decades before the husband and wife opened their shop on Palmer Avenue in Falmouth, and years before they opened their original deli in Cambridge, Elsie and Henry were part of something much greater. They were 2 of the 282,000 Jewish citizens who fled Germany in the years leading up to the start of World War II in September 1939.

Elsie was born in Nuremberg, Germany, and lived in the country with Henry and their two young sons as Hitler and the Nazi Party gained power. Before something terrible could happen to the family, the Baumanns left their home country and immigrated to the United States. They settled down in the town of Cambridge, Massachusetts, to begin a new chapter in their lives.

Things would start slowly in America for the Baumanns. Upon arrival, they both spoke no English and had a mere four dollars to their names. They learned the language and worked hard to save money for several years in Cambridge before taking their first major step forward. In the late 1940s, the couple purchased a small shop in the Boston suburb and

Elsie's in Falmouth. *Courtesy of Falmouth Historical Society.*

named it Hunter's Lunch. Their first step forward would last only four years, as the property was taken by eminent domain to make way for the new Southeast Expressway.

In 1955, Elsie and Henry got another chance, and it paid off in a big way. That year, they opened a sandwich shop named Elsie's Lunch in the Harvard Square section of Cambridge. It specialized in German food but became well known for a pair of sandwiches: the "Fresser's Dream," a heaping portion of meats, including ham, turkey and corned beef, and Elsie's "Roast Beef Special." The thinly sliced meat was topped with onions, German mustard, Russian dressing and relish. The best part of all was that these scrumptious sandwiches were only fifty cents.

Elsie's attracted people from all around. It included students and staff from nearby colleges and John and Robert Kennedy. The sandwich shop opened every day at 6:00 a.m., with Elsie as the face of the establishment and Henry as the soul of it. However, the daily grind took its toll on Elsie. She was often there until 2:00 a.m., making sure everything was clean. This attention to detail caught up with her in 1965, and she had a heart attack. It made it impossible for Elsie to continue a full-time schedule. She and Henry made the difficult decision to sell their immensely popular establishment shortly thereafter. It was particularly difficult, as the little sandwich shop

was selling between 1,200 and 1,500 roast beef sandwiches every day. The Baumanns found the perfect new owners in Philip and Claudette Markell. They agreed to not change Elsie's even in the slightest, which eased the Baumanns' pain of leaving their business behind.

The Baumanns retired to travel after selling their Cambridge establishment, returning to Germany nearly thirty years after leaving. After traveling for a time, the family came to Cape Cod and settled in Falmouth. However, the down time started to wear on them.

Only a year after selling their Cambridge restaurant, Elsie and Henry purchased a new restaurant and re-created Elsie's Lunch for the Cape in 1966. It had much the same menu as the Cambridge spot, with the Fresser's Dream and Roast Beef Special becoming popular to an entirely new clientele. The couple had expected their new venture on Palmer Avenue to be a quiet lunch venture. In a fitting tribute to the quality of the food, there were routinely lines out the door of hungry patrons waiting to get their share of the delicious sandwiches.

Despite not being nearly as booming as its Cambridge counterpart, Elsie's in Falmouth was a success and a staple of Falmouth's restaurant scene for twenty years, until Elsie and Henry decided it was time to retire, again. They came from Germany just before the outbreak of World War II with no money and speaking no English and ended up with not one but two successful restaurants in Massachusetts.

The Cambridge original Elsie's lasted until 1994, and as of 2016, the Boloco burrito shop stands where this icon once did. Henry and Elsie were married for fifty-eight years, separated only by Henry's death in 1991. Elsie passed in 2002. They left behind not only a legacy in the restaurant business but also, and more importantly, a legacy of hard work, survival and perseverance as they made their way thousands of miles from their homeland to escape the growing evil of the Nazis.

As of 2016, Crabapples Restaurant stands where Elsie's stood on Palmer Avenue in Falmouth.

THE FLUME

Address: 13 Lake Avenue, Mashpee
Years Active: 1972–2004

Cape Cod has a rich and proud Native American lineage. There are hundreds of places from one end of the Cape to the other that are named after or have deep connections to the Native American tribes that inhabited the area. The Wampanoag tribe is synonymous with the Native American lineage of the Cape, and members are still a big part of the area, making their tribal headquarters in Mashpee. There is also a strong contingent of Wampanoags in Aquinnah on Martha's Vineyard.

The Wampanoags are a proud people who cherish and honor their culture and legacy. It extends from their language and clothing all the way to the foods they eat. The cuisine of this distinguished tribe was on full display for three decades under the watchful eye of a true Native American chief.

The Flume Restaurant, located along the herring run in Mashpee, was successfully run by Wampanoag Native American chief "Flying Eagle" Earl H. Mills Sr. Mills was born and raised in Mashpee. He attended Mashpee schools until high school, when he transferred to Falmouth. After graduating in 1946, he entered the U.S. Army and served in Korea. After graduating from Arnold College in Connecticut in 1952, Mills spent the rest of the 1950s teaching at his alma mater, Lawrence High, in Falmouth. He also was a youth sports coach throughout the 1950s and '60s.

Mills was born to lead and inspire. In perhaps his greatest honor, he was named chief of the Wampanoag tribe in 1956 at a ceremony in the Old Indian Church on Meetinghouse Road in Mashpee. Mills was declared to be in charge of all council meetings and was at the top of the chain as far as tribal affairs went.

Mills learned to cook from his parents, Emma Oakley Mills and Ferdinand Wilson Mills, and began gaining skill as a gourmet chef in some of the finest kitchens Cape Cod had to offer. He spent sixteen years working dinners at the Coonamessett Inn in Falmouth between 1953 and 1969 and twenty-three summers at the Popponesset Inn in Mashpee between 1948 and 1970. He also gained great experience working alongside his mother, Emma, on an annual buffet dinner between 1959 and 1974 that was a fundraiser sponsored by the Mashpee Old Indian Meeting House Authority Inc. With so much experience under his belt, it was only natural that the born leader Mills would have the desire to open his own establishment.

He would get his chance in 1972, opening the Flume in his hometown of Mashpee with his then wife, Janice. The name came from the dam used to raise and lower the water levels in the cranberry bogs. Mills's mother, Emma, passed away that same year, which made the opening bittersweet. Located along the herring run near Mashpee Pond, his establishment was a way for Mills to share his native Wampanoag cuisine with a greater audience. The two-thousand-square-foot building sat eighty-four at capacity, which was often.

Use of local ingredients and staying loyal to his native culture was paramount for Chief Flying Eagle to find success with the Flume. Mills's father, Ferdinand, made the very first salt codfish cakes, and that recipe remained in use all the way through the Flume's existence. The popular cakes were served with beans. Marinated herring was a large part of the menu. Shad roe, a delicacy made up of the eggs of the shad fish, a type of herring, was also popular. The eggs were breaded in cornmeal and sautéed in butter. For every native dish Mills served, there were also traditional takes on fried fish, pot roast, corn and clam chowders for the less adventurous palate.

Perhaps most beloved of all at the Flume was the Indian pudding. Served warm with ice cream, it was something not to be missed on any visit. As the years went by, this spot became a destination for those wishing to sample authentic Wampanoag items or just enjoy expertly prepared versions of well-known local foods. Led by Earl Mills Sr. and his unwavering dedication to preserving his culture, the Flume extended a taste of the Wampanoags to

all of his loyal customers, including acting legend Paul Newman. Mills did his people honor by sharing the cuisine and also employed countless other members of the local Wampanoag tribe.

In addition to running the Flume, Mills wrote two books: *Son of Mashpee, Reflections of Chief Flying Eagle, A Wampanoag* in 1996 and the *Cape Cod Wampanoag Cookbook* in 2000. The cookbook featured several Flume recipes, including quahog chowder, coleslaw and the famed Indian Pudding. It also featured his father's recipe for corn bread and his mother's recipes for fish chowder deluxe, fry bread and hot milk cake. These books were another way Mills was able to share and preserve his native culture.

After thirty years of service, the time came for Mills to sell. In 2004, he relinquished the role of owner and chef of the Flume by selling it to Kenneth McNulty. Sure, he was seventy-six years old, but Mills had no intention of retiring; it was simply the next step in life for this pillar of the Mashpee and Wampanoag community. McNulty kept the Flume name but immediately changed the menu, removing the native dishes Mills had served. It became the Taylor Family Restaurant before closing.

As of 2016, the former chief of the Wampanoag tribe is still going strong at the age of eighty-eight. He still lives in his hometown, and the building on Lake Avenue is still vacant.

High Brewster Restaurant and Inn

Address: 964 Satucket Road Road, Brewster
Years Active: 1929–2001

It was a building steeped in history with a name to match. High Brewster has a legacy going back nearly three centuries, and to this day, its name is still known on Cape Cod. The name adorns the mailbox along Satucket Road in Brewster, while the home is set back from the road. For those who have only come to the Cape recently, the name and the building might have next to no meaning. For those who had the chance to visit and dine at this wondrous establishment, High Brewster is in a class of its own.

The story of High Brewster began in 1738, when Cape Cod was still in its relative infancy. Overlooking Lower Mill Pond, the two-story farmhouse was originally the home of Nathaniel Winslow. It would remain a part of the Winslow family for generations, serving as their homestead. High Brewster played a part in the abolitionist movement in the pre–Civil War days; there have been documented "secret" passageways at High Brewster, including one behind the main house's fireplace. These were used to help shelter runaway slaves heading north on the Underground Railroad.

As the twentieth century dawned, High Brewster garnered a measure of notoriety as part of a tour put on by the Town of Brewster of four of the most important historic homes in the town. This would be the only stray from the norm at the homestead for the first two hundred years of the property's

existence. It would continue to be a family home and passed down by the Winslows until reaching Mary (Winslow) Cleverley.

In 1929, the three acres of High Brewster were left to Mary. She and her husband, Frank, moved to Brewster from Norwalk, Connecticut, to claim the family's homestead. As the estate was steeped in history and offered a gorgeous view, Mary and Frank decided it would be nice to share what the Winslow family had been able to experience with others. The couple opened High Brewster up as an inn, allowing visitors and locals alike the opportunity to stay on what was celebrated family ground. The Cleverleys' risk in opening up their private home paid off in spades. High Brewster went from being a historic home and part of the Winslow family to a sublime location to spend a night or weekend.

Mary and Frank continued to run High Brewster as an inn until the outbreak of World War II in 1941. The inn was shuttered and returned to being a family home for nearly a decade. There would be another change to High Brewster in 1950—perhaps the largest change the property had ever seen.

William Arbuckle had been summering on Cape Cod since 1935, coming down from his home in Yonkers, New York. Arbuckle purchased High Brewster from Mary and Frank Cleverley in 1950 and added a high-class restaurant to the already established inn. Later that decade, Arbuckle's partner, William Hyde, joined him at High Brewster, leaving behind a job working for NBC in New York City. Together, Arbuckle and Hyde added to the legacy of the legendary homestead by creating a warm, intimate atmosphere and coupling that with some of the best fine dining Cape Cod had to offer.

The dining experience at High Brewster was the stuff of dreams. Arrival up the long rocky driveway allowed the vehicles to make a soft crunch. Patrons were greeted at the front door of the building by a maître d'; in later years, this was the job of the beloved Brian Sheehan, who went out of his way to make each person feel like his best friend. Folks were then escorted to one of the three dining rooms located on the first floor. The second floor remained an inn, along with the four cabins located in the spacious backyard of High Brewster. These included the Pond Cottage and Barn Cottage.

The most popular of the three dining rooms was the Rooster Room. With its low ceilings, an appropriate amount of rooster artwork adorning the walls, intimate candlelit tables and rustic wood floors, it was a perfect feeling of escape from the daily grind. The overwhelming popularity of High Brewster was evidenced by the fact that, at times, folks wishing to dine there

High Brewster as it appears today. *Christopher Setterlund.*

on weekends had to order their entrées as many as four days in advance. The food was top notch, and the experience was one of a kind.

William Arbuckle ran High Brewster for thirty-five years, until his death in 1985. Walter Hyde remained, keeping up the legacy of High Brewster for a few more years until his retirement in 1988. After the end of the Arbuckle/ Hyde team, the restaurant was bought by retired Pennsylvania teacher Tim Mundy and his wife, Kathy, in 1994. The couple loved the restaurant and inn and meeting the people who came to dine and stay; however, the business was not for them. In 2001, they sold High Brewster to the Thorne family. The Thornes chose to own it as a private residence, effectively ending the run of High Brewster as an inn and restaurant. In the years following, there was extensive renovation done to the interior of the historic home, but the outside remained relatively unchanged. Hedges and trees obscure the home partially from view; however, the legacy of High Brewster remains, as its name still adorns the home's mailbox along Satucket Road.

THE INN OF THE GOLDEN OX

Address: 1360 Route 6A, Brewster
Years Active: 1967–1989

On Cape Cod, foreign cuisine restaurants have become quite common. It is easy for one to find places specializing in Italian, French, Portuguese, Mexican, Chinese, Thai and Brazilian foods, among others. One cuisine that has been difficult to find on Cape Cod is German food. However, for more than two decades, there was one German establishment that not only survived but also thrived on Cape Cod. In the town of Brewster, the Inn of the Golden Ox was a popular spot to dine and also spend the night.

The story of the Golden Ox began back in 1828. Long before it would become a restaurant and inn, the spot at the corner of Route 6A and Tubman Road was a church. The First Universalist Church of Brewster operated from 1828 until the congregation grew too large and the church had to move to a larger building in 1852. The building went on to be called the Tip Top House.

In 1967, John Schwalbe and his wife, Marie, purchased the Tip Top House and transformed it into the Inn of the Golden Ox, a bed-and-breakfast as well as a rare German restaurant. John had immigrated to the United States in 1926 with his parents, bringing their native cuisine with them. He was born in Aachen, Germany, the westernmost city in the country, close to the border with the Netherlands. The restaurant featured John as the chef and Marie as the hostess and baker.

The small and intimate dining areas gave the Golden Ox a cozy feel. The old wooden floorboards and European-style closed-patterned wallpaper added to its charm. For all of the aesthetic appeal, it was the cuisine, labeled "fine German specialties," that would truly make this spot stand out. The red checkerboard tablecloths provided the backdrop for exquisite offerings on the menu, which was written in German.

There were appetizers like beef and mushroom broth, lentil soup, corn chowder and Dutch herring salad. The main entrées, lunch or dinner, were stacked with fresh cuts of meat and produce and several types of schnitzel. This is a flattened meat breaded and fried. The Golden Ox schnitzels were spectacular and included Weiner Schnitzel, Schnitzel Cordon Bleu and Schnitzel Oskar (with crab, asparagus and béarnaise). Other German delights like Sauerbraten (a German pot roast) and Weiner Rostbraten (meat with braised onions) dotted the menu.

The choices for dessert were heavier fare, such as German chocolate cake. Of course, there was also a healthy supply of fine wines and beer. This included the very popular Austrian Gumpoldskirchen wine for a time. All of the food and beverages were brought to the table by wait staff in traditional German garb, including lederhosen and suspenders. It was old-world Germany on the mid-Cape.

The Schwalbes decided to retire in 1972 and sold the Inn of the Golden Ox to Charlie Evans and his wife, Ruth. The couple continued the success that the Schwalbes created, even getting the ten-room inn featured in the Guide to New England Country Inns in 1979. Both Charlie and Ruth would do the cooking, alternating between the front and back of the house. They continued the atmosphere the Golden Ox had of being like having dinner at the home of a friend. It would keep bringing patrons back for the duration of their ownership. The Evans remained at the helm of the Golden Ox until 1983, when they decided to sell it to David and Eileen Gibson, who had moved to the Cape from Vermont. Sadly, Charlie passed away within a few months of the sale.

The Gibsons ran the inn for a few more years before selling it in 1989. Later that same year, the spot reopened as as the Beechcroft Inn, owned by Robert and Maureen DeRevere. Ownership was eventually transferred to Paul and Jan Campbell-White, who ran it until selling it in 2005. It would then be briefly known as Tilden's Landing in 2005, but that establishment was never officially open for business. Since then, it has not been run as a restaurant or an inn.

JOHNNY YEE'S

Address: 228 Route 28, West Yarmouth
Years Active: 1967–1992

In the 1960s and '70s, Cape Cod had its share of restaurants that served delicious, high-quality food. It also had its share of restaurants that showcased tremendous entertainment. There were even some great Chinese and Polynesian restaurants. However, only one spot could combine it all. Only one spot was Johnny Yee's.

Located along a busy stretch of Route 28 in West Yarmouth, Johnny Yee's was more an experience than just a simple restaurant. It was an attraction as much as it was a place to bring the family for dinner.

Johnny Yee's eponymous restaurant on Cape Cod was not his first successful venture in the state of Massachusetts, or on Cape Cod for that matter. In 1963, Yee and his business partner began their first endeavor on Cape Cod. Yee took his combination of authentic Polynesian cuisine and high-quality entertainment to Main Street in Hyannis, where he helped to create the Dragon Lite Restaurant. More than fifty years later, this spot is still open and going strong at 620 Main Street. It was a great starting point for Yee; however, he knew he could do more.

Two years later, in 1965, Yee, a Chinese immigrant, opened the award-winning Hu Ke Lau Polynesian restaurant in Chicopee, Massachusetts. It was in this setting that the mix of intimate dining and raucous floor shows was developed. It was and still is a huge success run continuously by the Yee

family. Hu Ke Lau remains open and running strong as of 2016 and is now a legendary establishment in western Massachusetts.

In 1967, four years after starting Dragon Lite and two years after starting Hu Ke Lau, Yee decided to branch out once again. Yee's search returned him to the Cape. Due to the high volume of traffic along Route 28, Yee focused his exploration on the mid-Cape area. He took over the location at 228 Route 28 in West Yarmouth formerly occupied by a place called Rooster.

In September 1967, the place was christened Johnny Yee's, and the rest is history. The Chinese and Polynesian cuisine brought people in for lunch and dinner, while the evening shows kept them coming back over and over. In the 1960s and '70s, some incredibly talented musicians called the stage at Johnny Yee's home at one time or another. "We had a Hawaiian show," he said, "jazz bands like the Count Basie Orchestra, Bobby Rich, Jimmy Dorsey, Tommy Dorsey, Woody Herman, Glenn Miller and more. All the big bands of that moment played at my place."

Perhaps the crowning achievement of the entertainment wing of Johnny Yee's is the jazz album recorded there. In the early 1970s, an album titled *An Evening at Johnny Yee's* was put together featuring legends of jazz Lou Colombo, Dave McKenna and the Magnificent Seven. Today, it is a terrific throwback to a bygone era on Cape Cod.

As they always do, times change. In 1991, Yee felt it was time to once again branch out. This time, he left the mainland United States to do so. He moved to Puerto Rico and opened a new venture called Peacock Paradise in San Juan. It was located inside the Caribe Hilton Hotel.

"It was a magnificent, splendid design," Yee fondly recalled. The next year, Yee sold his restaurant in West Yarmouth and moved down to Puerto Rico. However, he did not retire or even slow down.

"I continued to branch out in Puerto Rico and Aruba," Yee said. "My journey in the food and beverage business has not finished. By 2006, I had a total of seventeen restaurants, including fast food in different malls in Puerto Rico."

Yee still has a home on Cape Cod and visits often; he even said that the Cape will be his place of retirement when that time eventually comes. As for his famed West Yarmouth restaurant and entertainment complex, Yee remembers it and his loyal customers warmly.

"We had a lot of good customers," he said. "We used to do catering for people; everybody loved our food, our place and our old-fashioned way."

More than twenty years after closing, Johnny Yee's people still drive by the building and reminisce. It was certainly one of a kind.

As of 2016, an Asian-style buffet restaurant sits in that same building.

MARI-JEAN'S

Address: 680 Main Street, Hyannis
Years Active: 1968–1990

It was a place run by family with a staff that became like family. Located at the western end of Main Street in Hyannis, Mari-Jean's provided a wide variety of menu items in a superbly kitsch atmosphere for more than two decades. It attracted average joes, celebrities, politicians and Secret Service. It served its customers as well as the community.

The restaurant business was in the blood of Mary and Gene Bernier. Born in Granby, Quebec, Canada, Gene learned the business under his mother, who was chef at the famed Château Frontenac in Quebec City. After immigrating to America, Gene became chef at several Cape Cod institutions, including the Neptune Room at the Barnstable Airport and the Allen Fredericks House, located near the Airport Rotary in Hyannis. It was here that Gene met Mary, who was working there as well. She was born in Newark, New Jersey, and came to the Cape from Brockton. After working at the Chatham Arms Inn, Gene decided it was time for them to strike out on their own.

The couple found a suitable home at 680 Main Street in the building formerly occupied by the Lobster Shanty. It was the sister restaurant to the Fish Shanty, which was located at the other end of Main Street; both were owned by Elaine and George Karath. The new venture started in 1968 combined the couple's first names with a French twist. Mari-Jean's was born.

Mary handled the majority of the décor, with Gene taking care of the food. The white building housed three dining rooms and could seat 140 people. The Gold Room was front and center on entering the establishment under the white awning walkway. The MacFarlane Room was located in the back alongside the Antique Lounge. The third dining room, to the left of the entrance, maintained a very 1970s vibe with wood paneling on the walls. The interior was rustic yet elegant, perfect for a semiformal establishment. There was hand-carved wood from Canada and barn board walls mixed with beautiful tablecloths and candlelight.

In the kitchen, Gene made sure to use everything that came through the door, never wasting anything and placing a huge emphasis on making things from scratch. The dedication to freshness went above and beyond what was to be expected. At Mari-Jean's, many dishes were prepared or finished right at the customer's table. Caesar salad—dressing and all—was put together by the trained staff as patrons watched. Trout Almondine was cooked whole in the kitchen and de-boned at the table. Duck a L'orange was flambéed at the table. It was this supreme quality and freshness that made Mari-Jean's hugely popular.

The establishment boasted one of the largest menus on Cape Cod at the time. In addition to entrées like prime rib, paella and braised beef bordelaise, there were unique touches that filled out the menu nicely. There were spectacular flaming Irish coffees and flaming Spanish coffees; the dessert menu featured incendiary desserts like bananas foster and cherries jubilee. Regular customers were often split into two camps, one group who ordered the same exact thing, and others who made it a point to sample as much of the menu as they could.

The fabulous cuisine and stylish décor was made better by the tremendous staff. Many of the employees at Mari-Jean's stayed for long durations, with some still maintaining close bonds to this day. The staff would get together for Thanksgiving at the restaurant, closing down technically but opening the doors to any patrons who might have stopped by out of curiosity. The leftovers from that meal were brought to the local shelter. On one Sunday each month for two decades, the members of the Mari-Jean's family cooked a meal for the homeless and delivered it to the shelter. They served their customers and their community. They even served liquor to a special few regular customers during the off-season despite only having a seasonal liquor license for the first three years of the restaurant's existence. In the winter, Mari-Jean's had a double-life as a modern-day speak-easy.

Mari Jean's in painting form. *Courtesy of Mary Ann Taylor.*

The restaurant's popularity meant reservations were needed at the year-round hot spot. If one lacked a reservation, it was common to wait over two hours for a table to free up. This was only exacerbated by Mari-Jean's proximity to the hopping Melody Tent. It became common for celebrities to frequent the establishment before or after their performances at the entertainment center. Patti LaBelle, Florence Henderson, Rock Hudson, Jim Nabors and others could be seen inside the walls at various times. The popularity of Mari-Jean's allowed for Mary and Gene to purchase their next-door neighbor and use that space to create the Back Room.

Mari-Jean's became a special place to celebrate weddings, anniversaries, birthdays and other occasions. It was also a steady and stable presence, with the décor and the menu remaining virtually unchanged throughout its tenure.

Sadly, Gene Brenier passed away in 1988. Mary and her daughter Mary Ann did their best to keep the establishment running. The economic recession of the late 1980s that claimed several other Cape Cod restaurant mainstays took Mari-Jean's. Mary and Gene had owned the business but not the building it resided in; increases in rent, coupled with the recession,

forced a sale in 1990. Mary Brenier retired to Florida, where she passed away in 1994.

The building at 680 Main Street remained vacant for several years before being purchased and turned into the Brazilian Grill. As of 2016, it still stands at the site of the former Mari-Jean's in the same building but for the new glass room.

THE MAYFLOWER RESTAURANT

Address: 334 Main Street, Hyannis
Years Active: 1929–1987

Perhaps the original Cape Cod franchise, the Mayflower Restaurant began as one spot in Hyannis and grew to be several restaurants, with management expanding to hold other Cape properties as well. The original establishment was ahead of its time when it opened and continued to be a hugely popular dining spot for more than six decades.

The Mayflower's origins go back to the 1920s, when Main Street in Hyannis was a lot different. In 1929, a group made up of James Pazakis, George Garoufes and Peter Panesis initially opened the Mayflower at a

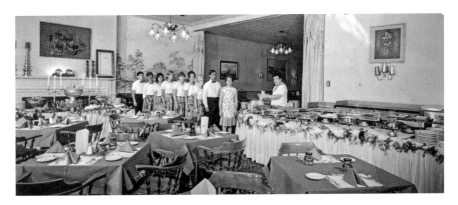

The Priscilla Alden Room at the Mayflower. *Courtesy of Nick Joakim.*

smaller location on Main Street. When it opened, the restaurant sported a black-and-white tile floor, a mahogany and crème color scheme and mahogany tables with black marble tops. There would be a separate counter seating fifteen people set apart from the dining room, which sat fifty. The first few years of existence for the Mayflower were nothing spectacular. However, in 1932, the restaurant gained a new partner, and things would never be the same.

John Joakim, who resided in Pennsylvania at the time, had come to Cape Cod to visit his friend James Pazakis for a week. While on the Cape, Joakim reached a deal to buy Peter Panesis's share in the Mayflower for $500. Joakim's week vacation became a lifetime stay. Under the new management team, the Mayflower experienced a popularity boom that took it from being a one-off eatery to a juggernaut on Cape Cod. The group took out a $5,000 loan in 1932 to expand the Mayflower in a time when the Great Depression was gripping the country. The new Mayflower opened at 334 Main Street, adjacent to the original location.

The Mayflower grew in stature through the 1930s, becoming a signature stop for diners in Hyannis and the surrounding areas. It was the hub of Cape Cod in a time when the Cape was not the vacation destination it is today. It was only natural that a place so overrun with business would need to expand. First came the Mayflower Café and then the addition of the Mayflower Sea Grill, at 380 Main Street. This was followed by a sister Mayflower Restaurant built on Main Street in Dennis Port in 1937. It was open in the summer and run by Thomas Grammaticas, the night manager of the Hyannis Mayflower. Finally, there was the Parisian Delicatessen and Bakery at 378 Main Street in Hyannis, opened in the spring of 1939. This spot came to be after the Mayflower won first prize at the New England Hotel Exposition in Boston in 1938. This honor was due to their pastry chef, Augustine Canut, who wowed customers with his fancy pastries from 1932 to 1940.

The management group of Joakim, Pazakis and Garoufes renamed itself Mayflower Inc., in deference to its monumental expansion in the 1930s—three properties on Main Street in Hyannis alone after the dissolution of the Sea Grill. Despite the expansion to multiple ventures, it was still the original Mayflower Restaurant that was the crown jewel. The block where the restaurant stood was, and still is today, known as the Mayflower Block on Main Street. John Joakim was front and center for the success of the Mayflower group with his hard work, friendliness and sincerity.

It was Joakim who decided to use the Mayflower's resources to feed the poor on holidays such as Thanksgiving and Christmas, beginning during the throes of the Depression. As the 1930s drew to a close, the Mayflower expanded yet again, with catering. It was the first real catering business on Cape Cod and ended up rivaling the restaurant itself in terms of stature.

The Mayflower and its management were riding high into the 1940s. In 1943, the café burned to the ground, but it was resurrected in 1945. Mayflower Inc. would again expand its horizons, purchasing the Column Terrace hotel in Falmouth in 1946. It was part of the Mayflower family for ten years. Before the decade ended, the Dennis Port Mayflower was shuttered. With the burgeoning catering business, coupled with the immense popularity of their original establishment, the owners decided to double down on the original Mayflower.

Behind the restaurant, facing Barnstable Road, a pool hall, Elk's club and telephone building were all leveled to make way for the spectacular fine-dining Priscilla Alden Room in 1953. This addition had its own separate entrance at 8 Barnstable Road. The new side of the Mayflower showcased a fabulous buffet that featured prime rib, and it was popular for weddings and private parties.

The Mayflower catering business hit its peak in the 1950s and '60s. It began in 1957, when it was hired to cater the arrival of the replica *Mayflower* ship in Plymouth. Two great Mayflowers were united, and nearly three thousand people were fed. The Mayflower catered to the Kennedy family at their compound in Hyannis Port and also served the military at Cape Edwards. In 1964, John Joakim retired, and his two sons, Nick and Jack, took over the reins of the iconic establishment.

The quality and popularity did not waver. People came from all over to enjoy favorites like pot roast, liver and onions, high-quality seafood, corned beef and cabbage and perhaps the biggest favorite of all, the hot hamburger served with gravy and French fries. The tireless dedication of the Joakims came through with their quality of food and service to the customers both inside the walls of the Mayflower and Priscilla Alden Room and also through their catering business. At times, it seemed as though the restaurant was open twenty-four hours a day.

Things began to change in the 1980s. John Joakim passed away in 1987, and the Priscilla Alden Room was renamed John's Loft in his honor. In the front of the house, the Mayflower itself was renamed Sophie's, the name of Nick's wife. But it was still run by the Joakim family. By 1992, the family felt it was time to sell their establishment. It would be run for a time as

T. Rossi's and then Hooters. As the twenty-first century began, it became Tommy's Doyles. As of 2016, KKatie's Burger Bar occupies the spot at 334 Main Street.

Few restaurants have ever achieved the popularity and longevity of the Mayflower Restaurant. At one time it and its sister establishments dominated Main Street Hyannis. It was a juggernaut of great food and great people led by John Joakim. Passersby can still look up high on the façade of the Mayflower Block and see the ship carved into it, hearkening back to when the Mayflower was the hub of Cape Cod.

MILDRED'S CHOWDER HOUSE

The Home of Cape Cod Clam Chowder.

Address: 290 Iyanough Road, Hyannis
Years Active: 1949–1999

Long before there was a yearly chowder festival held on Cape Cod, there was one restaurant that could lay claim to being the king of clam chowder. Mildred's chowder was so beloved that everyone from presidents to average joes flocked to the cozy establishment abutting the Barnstable Airport. In the forty-plus years it was in existence, this restaurant and the name Mildred became one of the most popular establishments the Cape had ever seen.

Before she opened the legendary Chowder House abutting the Barnstable Airport, Mildred Desmond ran a smaller restaurant located diagonally across the street, in the area where the Quarterdeck Lounge stands as of 2016. It was more a coffee shop than a full-fledged restaurant.

In 1949, she opened the restaurant that bore her name with her two sons, Bernie and Jim Desmond. It was a much quieter time on Cape Cod in the years just after World War II, but the Desmond family created mouthwatering dishes that soon set the senses aflame of any customer who passed through the doors.

In the early days of Mildred's Chowder House, the competition was much different than that of its later years. Mega-chains and fast-food spots would not come creeping in until the 1960s and '70s. Back then, it was other one-

Mildred's Chowder House. *Courtesy of Sturgis Library.*

off establishments, many run by families like the Desmonds, that dominated the scene. Quality and service were how these places got popular; it was often an uphill climb to build a reputation.

Mildred Desmond did not fear the hard work it took to give her eponymous restaurant the glowing reputation it developed. She served up fresh local seafood, including classics such as fish and chips, clams, scallops, lobster and shrimp. As tempting and necessary as the abundant seafood offerings were, the Chowder House also dipped into steaks and chicken dishes as well, in case there were any customers who were not fans of meals from the ocean's waters.

Of course any restaurant with *chowder* in the name had better make a worthwhile representation of the New England favorite. Mildred's succeeded in making a truly legendary clam chowder that is still talked about to this day. How popular was Mildred's chowder? President John F. Kennedy ordered the base from the Summer White House in Hyannis Port. He also ordered a specially made lobster stew made by Mildred's son Bernie. It consisted of only knuckle meat; it took twenty-five pounds of lobster to get a pound of knuckle meat for the president's stew. Mildred's chowder recipe was often imitated and never duplicated. A former employee even sent in the recipe as they remembered it to the *Cape Cod Times* newspaper in 2008, helping many

people longing for another taste make it themselves. Of course, the recipe has to be scaled down, as only large batches of the sumptuous soup were made.

The restaurant featured a casual down-home atmosphere and traditional Cape Cod décor, with fishing and the ocean adorning the walls and ceiling. Locals loved it, and soon word began to spread about the little restaurant next to the airport. In the early 1960s, there was even entertainment at Mildred's. At one point, the happy hour featured Cape Cod's First Lady of Jazz, Marie Marcus. She played there for about eight weeks along with Jim Blackmore and Carl German before moving on to Rooster in West Yarmouth, which later became Johnny Yee's.

Soon, the little restaurant grew too busy to have room for entertainment, and the Desmonds focused solely on the food. Mildred's became a destination for those vacationing on the Cape during the summer. It was in 1969 that things hit the tipping point and a large addition was attached to the little chowder house to allow the ever-increasing crowds to be served.

In the 1970s, it became commonplace for Mildred's to serve nine hundred customers a night for dinner, with a line out the door waiting to get in every night of the week during the summer from 5:00 to 9:00 p.m. Despite the addition, Mildred's was still too popular to fit all of its adoring public. It was necessary to have a staff of sixty waitresses and eight busboys each summer to handle the volume the establishment was putting out. Business was booming; Mildred's had become one of those rare restaurants that was known outside New England, being mentioned by newspapers in New York and Chicago.

The little chowder house had become a Cape Cod landmark. In the early 1980s, Mildred's sons, Jim and Bernie, sold the restaurant. Despite the ownership change, its legacy continued, even as things around the restaurant were changing, with an influx of big chain restaurants like Chili's and Pizzeria Uno and an increase in fast-food spots like Wendy's and Kentucky Fried Chicken.

In the 1990s, business began to slow down at the iconic Mildred's, and the restaurant was sold again. Then, after five decades of building a reputation as one of the premier restaurants on Cape Cod, Mildred's Chowder House was sold a final time in 2000 to Mark Bobola. He renovated the property and reopened it as Fish Landing Bar and Grill. Nothing could replace Mildred's, and the new venture closed within two years. The empty building was discussed as a possible homeless shelter in 2003, but nothing came of it. It was torn down in 2005, and as of 2016, all that remains of Mildred's is the overgrown parking lot.

For more than five decades, Mildred's Chowder House was one of the most popular restaurants the Cape had to offer. Its chowder is the stuff of legends, and countless people still speak of it to this day with adoration. Places like Mildred's come once in a generation and are not easily replaced—neither are the memories of it.

THE MOORS RESTAURANT

Address: 5 Bradford Street Extension, Provincetown
Years Active: 1939–1998

Provincetown's Portuguese heritage goes back more than 150 years. In 1840, Portuguese sailors began arriving in Provincetown as extra hands on fishing and whaling vessels. Since then, their influence and legacy have become widespread. It was a Portuguese fisherman who brought the first gasoline-powered engine to the fishing fleet in 1901. Immigration peaked in the 1910s and again between 1961 and 1990. Their influence can be seen today in the annual Portuguese Festival, which began in 1997.

There have also been several fantastic Portuguese restaurants lining the streets of Provincetown over the decades. Perhaps none has been as beloved as the Moors. It began as the dream of Maline Costa, a Portuguese immigrant, in 1939. Costa began his journey in Provincetown operating on a much smaller scale. He ran the Shed, a hot dog stand that grew into a popular bar next door to where The Lobster Pot still stands as of 2016 on Commercial Street. After working there for a bit, he decided the time was right to move up.

The Moors restaurant was built in the west end of town, with a tremendous view of the salt marsh; these were "the moors" for which the establishment would be named. Costa wanted to have a spot that served his native Portuguese-style cuisine but had the flavor of Provincetown mixed in. He would succeed in a major way.

The Moors menu cover. *Courtesy of Provincetown History Preservation Project.*

Also a carpenter and contractor, Costa adorned the walls of the Moors with fishing and whaling paraphernalia hearkening back to the town's whaling heritage and giving a nod to the still-important fishing industry. The beginning was slow going, though, as the Moors was patronized mostly

by those going to and from nearby Herring Cove Beach, then called New Beach, during the summer. Things did pick up as word got out about the fabulous Portuguese menu, including a traditional Portuguese soup that was so popular it became part of the Provincetown Portuguese Cookbook around the turn of the twenty-first century.

Stellar authentic entrées like the Caldeirada a Portuguesa (Portuguese fish stew), Linguica and cheese quiche and the Moors signature Porco em pau (pork marinated in herbs and spices) brought customers in and made them repeat visitors. In addition, the Moors also had a great selection of genuine Portuguese wines and the legendary Scooters Punch, made from three types of rum.

Business carried on well until a terrible fire in May 1956 leveled the Moors. This could have been the death blow to the restaurant, but the Costa family had become ingrained in the town. The loyal customers became loyal friends when they donated their time, efforts and distinct artifacts to rebuild the Moors better than ever. In fact, the establishment was rebuilt and reopened in a mere thirty days. It was a testament to the spirit of Provincetown and the indelible mark the Costa family had made on it.

Capitalizing on the good fortune, Costa erected a motel at 59 Province Lands Road, called simply the Moors Motel. This motel was unceremoniously welcomed to Provincetown the following year, when Hurricane Donna tore much of its roof off. Damage notwithstanding, the motel became a successful side to the main dish of the restaurant.

As the 1950s entered the '60s, the Moors added a Jazz Brunch, featuring renowned singer and pianist Lenny Grandchamp. He held court in the Jug Room for decades. If jazz piano didn't tickle one's fancy, then possibly a meal and a sing-a-long in the Old Shed would do the trick. The Moors might have specialized in Portuguese fare, but it had the ability to touch every person who walked through the doors no matter where they were from.

In the early 1970s, Maline Costa left the restaurant business behind, and his son Mylan and his wife, Jeannie, stepped in to continue the great tradition of the Moors. In 1992, the Costa family sold the Moors Motel to Diane Daren and Loretta O'Connor, who renamed it the Inn at the Moors. As of 2016, it is still open and going strong.

Mylan Costa decided it was time to retire in 1998. He sold the iconic Moors to John and Kim Medeiros and proceeded to write his own cookbook, featuring recipes from his family's restaurant. The couple ran the business until 2002, when it was shuttered for good. The Moors

was torn down and replaced by condominiums called Village at the Moors in 2004. As of 2016, they are still operating on the spot where the landmark restaurant once stood and still overlook the salt marsh for which it was named.

MY TINMAN DINER

Address: 70 County Road, North Falmouth
Years Active: 1941–2000; 2008–2011

The diner has been a part of American history for more than 140 years. It is a slice of a simpler time, filling the mind with images of the bustling counter and quickly prepared but delicious comfort foods served in a small, cozy environment. The first diner was created in 1872 in Providence, Rhode Island. Established by Walter Scott, it was a horse-drawn wagon with walk-up windows on either side. The first patent for a diner, then called a "night-lunch wagon," came in 1893. However, diners did not truly take off until the introduction of the Sterling Streamliners, inspired by streamlined trains, in 1939.

One such Sterling Streamliner became a staple in New Bedford. The Jimmie Evans Flyer was a Sterling built in 1940 and opened in 1941 on the southeast corner of the intersection at Pleasant and Middle Streets. The diner was purchased by Jimmie Evans, a former vaudeville entertainer. Evans became one of vaudeville's most well-known promoters, and at one point, he managed five groups of actors that toured the country. These included Ray Bolger, Bert Lahr and Jack Haley, who were the original Scarecrow, Cowardly Lion and the Tin Man in *The Wizard of Oz*, respectively.

After retiring from show business, Evans became postmaster in the neighboring town of Fairhaven. Though he lent his name to the diner, it was his wife, Kitty, who truly ran the establishment. It was successfully run in its

first location for nearly two decades before it made its first move, coming across the Cape Cod Canal.

In 1960, Sandwich resident Norman Welch, president of the Cape Oil Corporation, purchased the Jimmie Evans Flyer. It was moved across the canal to a location at the Otis Rotary in the Pocasset village of Bourne. The pine-paneled Sterling Streamliner was enlarged so it could seat fifty people inside, with Welch turning the kitchen over to his chef, known only as "Smiling Charlie."

The diner had a stable home and served up classic fare to its customers. However, despite the home being stable, the name of the establishment itself changed several times over the next two decades. In the twenty-five years under the ownership of Norman Welch, the Jimmie Evans Flyer became the Otis Rotary Diner in the 1970s and Mary's Muffins after that. Welch sold the business to Claire Bergeron of Wareham in 1985. In 1989, Bergeron leased the business to Barbara Lind, who had visited the diner as a child, and the Sterling Streamliner began its next chapter.

Upon leasing the diner, Lind changed its name to My Tinman Diner. This was in honor of her grandfather, who was a tinsmith and made toys for her. Tinman became Lind's life's work, as she spent all of her money to restore the diner. Piggybacking on the Tinman name, there was one of the largest collections of *Wizard of Oz* memorabilia in the world inside the walls. There was also a collection of POW and veterans' memorabilia inside. It made the décor of the diner second to none. As the 1990s began, many soldiers went off to fight in the Gulf War in Iraq. Some of the local men and women who went into battle hung their patches on the wall, hoping that they would be prayed for by the patrons of My Tinman. Each and every one of those soldiers did come home safely. Barbara's love of those in the service was apparent by the way she would get up before sunrise to enter the diner and prepare meals to be delivered to those at Otis Air Force Base. She did not have customers; she had a very large extended family.

Along with her daughter Susan Kettell-Lind, Barbara's dedication to giving customers the best possible experience at Tinman from food to atmosphere led to the diner being featured in several publications and books on popular eateries. All were welcome inside and treated like family no matter who they were or where they came from. The former Jimmie Evans Flyer was having its best years yet as My Tinman. Sadly, the good times did not last.

In November 2000, the diner was lost to a fire. The blaze, set by the jealous husband of a waitress who worked there, spelled the end of the wildly popular establishment. The loss was devastating to the regular customers,

who spent the next few weeks gathering to drink their morning coffee in the parking lot where the charred shell of the diner remained. The loss was even more devastating to Barbara, who felt the Sterling Streamliner was more than a restaurant—to her it was almost human. She had contemplated having a wake for the business in the aftermath. Eventually, Barbara Lind and Susan Kettell-Lind moved on with their lives. Barbara worked in the kitchen at the Riverview School in Sandwich and the Plymouth Bay House, while Susan went back to college.

It seemed as though My Tinman would remain in the past until a stroke of luck brought it back to life in 2008. The North Falmouth Diner, located at 70 County Road, was up for sale, with the possibility of it being bought and simply torn down. Susan leased the diner from the owner, and thanks to more than $50,000 in donations, the structure was renovated. It was renamed the Tinman Diner, and the *Wizard of Oz* motif was re-created inside.

The revival of the diner would last for three years, until an amicable parting of ways with their landlord spelled the end of the Tinman Diner for Barbara and Susan in April 2011. The diner briefly reopened as Boxcar's Diner in 2012. Seven decades after the Jimmie Evans Flyer first opened in

The Tinman Diner site in North Falmouth as it appears today. *Christopher Setterlund.*

New Bedford, the legacy of the diner was laid to rest. Multiple locations, multiple names and countless satisfied customers—both regular and one-timers—made the Tinman Diner a spot not soon to be forgotten. Even today, years after its final closing, Barbara Lind thinks back on those great times and misses her horde of loyal regulars. "Every reunion was a happy one," Lind remarked, "and each parting was a silver tear. Only because they knew the Tinman would always be there."

It still is, in all of their hearts.

As of 2016, the location at 70 County Road, diner and all, is vacant.

NORTHPORT RESTAURANT

Home-cooked food with a Cape Cod flavor.

Address: 323 Route 28, Chatham
Years Active: 1964–1995

The town of Chatham is still every bit the quaint fishing village it has always been, even in the twenty-first century. In the mornings, at sunrise, one can stand on the shore of Lighthouse Beach and watch the fishing boats travel out into the Atlantic Ocean one by one off to take in their daily haul. Chatham, fishing and fresh seafood all go together seamlessly. One such spot that combined the quaint fishing village feel with a variety of freshly caught seafood was Northport Restaurant.

The Northport Restaurant is every bit a homegrown Cape Cod story. It began years before the restaurant opened. Future Northport owners Bruce Woodland and Anna (Olson) Woodland both grew up on Cape Cod in Chatham and graduated from Chatham High School. Bruce was a graduate of the class of 1946, and Anna graduated in 1954. After graduation, both would make their homes there.

In 1955, after serving his country in the army for six years, including two years in Korea, Bruce returned home and continued his work in the restaurant industry. He had started working at the Chatham Wayside Inn at age thirteen for Marjorie Haven. In 1957, Anna began working part time as a waitress at Wayside. In 1958, Bruce and Anna were married and started a family.

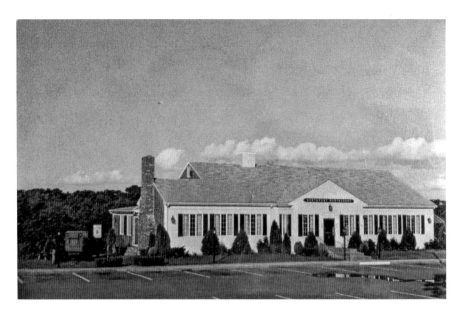

Northport Restaurant, Chatham. *Courtesy of Bruce and Anna Woodland.*

Marjorie Haven sold the Wayside in 1962 or '63. Her son, Robert, and his wife, Ruth Woodland Haven, started their own new restaurant venture, the Captain's Table. In June 1964, Bruce and Anna opened the first Northport Restaurant along Route 28 in a newly built shopping center. The name Northport was chosen by Anna as a compromise for residents wondering if the restaurant was located in North Chatham or Chatham Port. It was an instant success. The restaurant was open year-round—an immediate plus with the locals. Its bright and cheery décor, a cool green color with well-spaced tables, allowed the customers to fill the building yet not feel as if they were being intruded upon by the neighboring parties. In 1969, the second, larger Northport was built on a neighboring piece of land, where it remained for the rest of its existence.

Bruce, Anna and their staff worked hard to make customers enjoy and remember their time at Northport so that they would make it a regular stop. The Woodlands were a perfect team, with Bruce handling the kitchen and Anna managing the business end. As much as the décor and staff made supporters out of their customers, it was the variety of incredible dishes that really made Northport stand out. Being located in the fishing village of Chatham, naturally, Northport had an array of sumptuous seafood dishes on its menu, including the popular lobster bisque that was served Sundays.

A well-received Friday night buffet was a special highlight. Besides seafood, though, there was a surprising diversity of cuisine at Northport, including roast beef, lamb and a scrumptious salad bar meticulously prepared by Bruce and his capable kitchen staff.

In addition to the lunch and dinner selections, homemade baked goods stood out as well. The original house baker, David Youngblood, was a master and created mouthwatering selections. He could whip up cakes for special occasions. The famed oatmeal bread from the Wayside Inn was brought along to Northport. So talented was Youngblood that Bruce and Anna opened the Northport Bakery on Crowell Road to give him a larger place to share his skills and sell to the public. One summer season, the Chatham Bars Inn lost its baker, and Northport Bakery was chosen to supply its baked good needs for that summer season.

Bruce and Anna also made sure to help out their local community by staffing the restaurant almost entirely with local people. Most of the wait staff would be local Chatham girls, and the Woodlands believed that they were indeed lucky to have a willing and capable staff. The shopping center where Northport originally resided even included the Northport Variety Store, run by Bruce's parents. Good food at reasonable prices, a relaxed atmosphere and friendly, dedicated staff added up to make Northport a true Chatham institution.

In 1980, the restaurant was renamed Northport Seafood House to better emphasize seafood as a specialty of the house. It was extensively remodeled that winter, with Bruce doing most of the work himself. A nautical theme took over the décor, and the restaurant expanded from 68 seats to 175. The two dining rooms received unique names, with the larger Chatham Room and the smaller 1712 Room. There was also the After Deck lounge. In 1982, Bruce and Anna decided to retire and move to Florida to begin a new chapter in their lives.

First up was the sale of their beloved establishment. In answer to Anna's prayers, Anna's mother told her she heard that the Aucoin family was looking for a restaurant to buy for their sons to operate. Dr. and Mrs. Aucoin met with the Woodlands and made arrangements to purchase Northport. Their son Joe worked for the Woodlands in the time leading up to the actual sale to learn the business before they stepped away for good in March 1983.

The new regime at Northport made it into the mid-1990s before closing the iconic restaurant for good after two decades. In 1997, a new place, Giorgio's Cucina Del Mare, opened and closed within the same year. One year later, Bob and Lisa Chiappetta opened Campari's Bistro Bar & Grill

in the building. It had some success, blending family-friendly dining with live jazz music. It changed its name to 323 North under new owner Brian O'Keefe in 2012 but closed the next year.

In 1984, Bruce and Anna Woodland moved to Naples, Florida, where they became realtors. They still reside there happily today.

As of 2016, the building that housed the Northport Restaurant has been vacant since 323 North was shuttered.

THE PADDOCK

Address: 20 Scudder Avenue, Hyannis
Years Active: 1969–2014

W hen it came to combining first-class dining and a unique atmosphere, there were few that did it better than this Hyannis icon. The Paddock was revered for decades for its combination of a delicious, ever-changing menu and its never-ending party ambiance. This six-thousand-square-foot landmark located at the West End rotary was the showcase of legends and the cornerstone of many customers' lives. It was all thanks to the vision and dedication of its owner, John Zartarian.

The building that housed the Paddock for forty-five years has its own storied history that dates back before most of current Hyannis was built. In 1935, the future Paddock was constructed as a restaurant for the Dutchland Farms chain. In its day, it was seen as a rival to Howard Johnson. It began as a real dairy farm and grew into restaurants beginning in 1928. Its numbers would grow as high as fifty before being sold to Howard Johnson in 1940 and completely disbanded by 1951. The Hyannis location survived a few years before making way for a few other short-term ventures, including Newbury's Capeside, before it became the Paddock.

The Paddock came to be in 1969 thanks to Jack Riska, who would go on to also open Captain's Table in Hyannis, Captain's Chair in West Yarmouth and East Bay Lodge in Osterville. A year later, Zartarian and his wife,

Maxine, were looking for a restaurant of their own and purchased the new establishment, beginning their own storied Cape Cod careers.

Business was tough at first, as the couple struggled for money after spending so much to simply get into the Paddock. They both agree that if it had not been for the theater people playing at the neighboring Melody Tent who came to their establishment, they most certainly would have gone under in short order. Those lean early years made the Zartarians appreciate what would come later.

Times would change, however, and so, too, would the restaurant, albeit slowly. The Paddock had a high-class, formal atmosphere, but it did not require jackets or ties. Most customers wore them anyway. Shorts were not allowed, and hats were not to be worn while sitting. This rule was broken on one memorable evening in 1978 according to John Zartarian:

> *We used to sit any well known entertainers way in the back, so they wouldn't be bothered. Chuck Mangione comes in and he was known for his soft hat. Just coming off his huge hit ["Feels So Good"] he was set to play The Tent that night. I didn't say anything about the hat policy. Well he gets done eating and stands up in the back of the room and begins to play his hit on his trumpet as he walks through the restaurant to exit. A hundred people get up cheering and going wild.*

Encounters such as the one with Chuck Mangione were common at the Paddock, as it became a place for entertainers to eat and, at times, perform. There was the night that Tony Bennett sang "I Left My Heart in San Francisco" while house pianist Jimmy Silverman tried to keep his composure, later telling John his knees were literally shaking the entire time. Or the time that famed chef Julia Child came to dine and insisted on meeting the entire kitchen staff and having a photo taken with them.

As the 1970s ended, it was becoming difficult to serve everyone who wanted to dine at the Paddock. They were having to routinely turn people away. During a trip to Old Town in San Diego, California, the Zartarians were having a meal outside, and John got the idea to create an outdoor dining area at his restaurant. In 1980, Backyard at the Paddock was created. It would be complete with church railings, brass and marble. From this area, customers could hear the shows going on at the Melody Tent while enjoying their meals.

The Backyard became the place to be, with some waiting as long as four to five hours to get a table outside. It was a stark change from the Paddock.

Backyard was informal, with an eclectic menu. For eight years, it was an excellent alternative to the high-class Paddock, but a storm in 1988 damaged the dining area badly. Instead of closing down, the Backyard became the enclosed Garden Room, which was used for private parties and rehearsal dinners, among other things.

The entertainment and beautiful, diverse dining settings might have brought some to the Paddock, but it was the food that kept them coming back. It helped that the same chef, John Anderson, was the mastermind for thirty-five years. The menu was constantly changing, but there were always fresh fish and steaks to be had. The roast duckling had people raving, yet the most popular item might have been the baked stuffed lobster. The key? John Zartarian said it was never running out of lobster, ever. Even if it meant driving down the street to one of the competing restaurants in Hyannis and "borrowing" a few lobsters, Zartarian did it to make his customers happy.

Time passed, and the Zartarians opened a pair of new ventures: Aqua Grille in Sandwich and Del Mar in Chatham. As they approached their fourth decade at their West End locale, John and Maxine stepped back and allowed their sons to take over, John Jr. at Del Mar and Jeff at the Paddock. In the end, it was difficult to maintain such a high standard of quality at the Paddock; the product was expensive, as the Zartarians used only the highest quality meats and fish. In 2014, the Paddock was sold to Gary Roy, who created the Nor'easter Restaurant, which closed late in 2016. John and Maxine Zartarian live happily on Cape Cod and have nothing but fond memories of their forty-five years owning the Paddock.

"It was a party every night," John said. "We loved our business, we loved going to work. We had beautiful people working with us, and beautiful clientele."

THE REGATTA OF COTUIT

Address: 4631 Route 28, Cotuit
Years Active: 1987–2013

After summering in the East Chop section of Martha's Vineyard since childhood and spending decades working in marketing and advertising in the fast-paced worlds of New York City and Hollywood, California, Brantz Bryan decided to take on a new challenge: restaurateur.

He moved to Falmouth in 1970. Soon thereafter, an opportunity came up, and Bryan and a pair of partners purchased the Hurricane Deck Seafood Restaurant and the neighboring fish market to create the Regatta of Falmouth by the Sea. Bryan would state in an article in the *Falmouth Enterprise* in June 1970 that he was attempting to create a "simple and uncomplicated" restaurant. Located right on the harbor at 217 Clinton Avenue, it had a sea-worn exterior and a fabulous, elegant interior. The inspired menu, which included the very popular lobster corn chowder, was only outdone by the inspired dress of the new restaurant's owner. Bryan was famous for wearing Bermuda shorts and loud-colored sports jackets.

With business and acclaim on the upswing, Bryan began the expansion of the Regatta name. First, there was a motel. In 1973, he purchased the Belvidere Motel, which was located across the street from his restaurant, and christened it the Regatta Motor Inn.

In 1974, Bryan married Wendy Wile. Sharing his love of the restaurant business and the enthusiasm of great hospitality, she became instrumental

in helping the Regatta become more than just a single upscale restaurant. A trip abroad to France in 1983 helped the Bryans pick up cuisine ideas to add to their Falmouth establishment and became a catalyst as the Regatta found a second location twelve miles away.

By 1983, the Rowland Crocker House at 4631 Route 28 in Cotuit had been steeped in history. The Federal-style building was built in 1796 as the home of Rowland Crocker. Rowland was the grandson of Ebenezer Crocker Jr., who first settled Cotuit in 1739. The building became the first library in the village just after the turn of the nineteenth century. In 1821, it also became the village's first post office, with Rowland Crocker running it as postmaster until 1846.

Brantz and Wendy purchased the historic Crocker House and, after adding a kitchen wing, opened it as the Regatta of Cotuit. Bryan liked the Cotuit location, as it could provide year-round service and thus keep his staff employed. As with his Falmouth location, the Regatta of Cotuit specialized in upscale dining and high-quality food. The menu was dotted with delicious specialties like crispy duck, Statler chicken, prime rib, filet mignon, swordfish and salmon. French, Asian and New American accents became part of the fare thanks to the Bryans' travels, as well as their dedication to giving their clientele the best experience they could possibly have.

Though it had three dining rooms, the soft, subtle charm of the Tap Room made it a popular choice among guests. It had wood floors, a full bar, its own special menu and, like the other dining rooms, white tablecloths and candles adorning each table. Both of the Regatta locations were perfect for intimate, romantic dining.

In 2006, the Bryans sold the Regatta of Cotuit to Chef Weldon Fizell. Brantz passed away in 2009 in Florida, leaving behind a long legacy of hospitality and advertising and marketing genius.

Fizell remained true to the Bryans' vision of the Regatta of Cotuit. He had worked there in 1990 and was a graduate of Johnson and Wales. His time at the Regatta, Chatham Bars Inn and Coonamessett Inn in Falmouth gave him all the experience he needed to keep the success going, and he ran the Regatta until 2012.

The Regatta of Falmouth by the Sea was eventually sold and became Hutker Architects. It was completely renovated inside in 2005, and as of 2016, the office space is for sale

After it was sold in October 2012 to Peter Menounos, owner of Santuit Inn, it reopened for one more year in 2013 under the Regatta of Cotuit

Both: "the Best!"

"The *best* restaurant on Cape Cod...service as good as the food."
Boston Magazine

• 8 intimate dining rooms in historic Georgian mansion.
• Superb cuisine: New England & New American.
• Three menus: early, light & full course dinner.
• Open all year. . . 4:30 pm
• Jazz (soft-pedal) pianist.
• Fully air-conditioned.
• Comfortable prices & Comfortable attire.

The Regatta Of Cotuit

An advertisement for the Regatta of Cotuit, now Villaggio at the Regatta. *Courtesy of* Cape Cod Life *magazine.*

name. In 2014, it was again sold, this time to Jay Bartolomei, owner of Landucci Italia in Falmouth. It was rechristened the Villaggio at the Regatta and as of 2016 is still open and running in the Rowland Crocker House.

RENO DINER

Address: 48 Route 6A, Orleans
Years Active: 1942–1960

Most restaurants or businesses have names with simple origin stories. Many use the name of a proprietor, a takeoff on what they produce or a variation of where they are located to name their establishment. Then there are those rare cases where a business's name can take a good story and make it great. Such is the case of the Reno Diner in Orleans.

Diners became a staple of American culture during the first half of the twentieth century. The original diner was created by Walter Scott in 1872, running out of Providence, Rhode Island. It was a horse-pulled wagon with walk-up service. The first patented diner was given to Charles Palmer of Worcester, Massachusetts, in 1893. In the time just before and after World War II, diners were so popular that the streamlined train model diner was being mass produced and shipped to sites of prospective establishments across the Northeast and Midwest.

It was around this time that Reno Diner took its place among the diners of America, although it was different from most of the others.

Reno Diner was the brainchild of Joseph Davis. He and his wife were from the island of St. Pierre off the coast of Newfoundland. There, Davis worked at the French cable station, beginning in 1911. In 1919, he, along with a few others, was transferred to the French cable station on Route 28 in Orleans. Davis was transferred back to Newfoundland the following year,

but he made his way back to the Cape and made his home not far from the cable station.

When the station closed in 1940 because of the onset of World War II, Joseph Davis knew he needed another outlet to support his growing family. He enlisted the help of a few friends, and the next phase of his life began. An apple orchard was cleared out to make way for a diner. Davis, along with his son Robert and friends Rodney Sheperd and Ernie Fitzpatrick, constructed the classic train car–shaped restaurant in 1942. Before it opened, it naturally needed a name. This is where the diner's story goes from good to great.

There have been two conflicting stories of how Reno Diner got its name. The first is that when the neon sign—which was to have read "Orleans Diner"—was delivered, some of the letters were smashed and all that could be salvaged was R-E-N-O. The second story is that the Reno name came from a sign for the Norge Appliance Company, which was popular around that time. Sheperd and Fitzpatrick salvaged the R-E-N-O from that name. Either story is feasible.

Name chosen, Reno Diner was staffed with locals, including Davis's son Robert and daughter Henriette. It began with tight hours of 6:00 a.m. to 2:00 p.m. serving breakfast and lunch from its site along Route 6A just after it intersects with Route 28. The diner nearly died a quick death; only a year after opening, in 1943, Joseph Davis received an offer he could not refuse. New York City came calling with a job to work at the Press Wireless Office, which would hold him over until the French cable station in New York City reopened.

Reno Diner closed and lay dormant for a few years. After the war ended, Davis's daughter Henriette and her husband, Gordon Harris, resurrected the diner. Again, it was staffed by locals who gave it a community feeling. Gordon took Joseph Davis's idea to a new level with his culinary expertise and drive and made Reno Diner a must for locals and visitors alike.

Gordon came up with daily specials to go along with the classic diner fare. The counter and neighboring booths were routinely filled with happy customers. This led to the diner's hours being extended to all day. In addition to the locals and visitors making Reno Diner a happening spot, it was also populated frequently by the military. The convoys stopped for meals at the diner on their way to and from nearby Camp Wellfleet, with its army base and firing range. The camp occupied more than 1,700 acres of land among the Wellfleet dunes from 1942 to 1961 before being declared excess and gifted to the Cape Cod National Seashore by President Kennedy.

In the 1950s, Reno Diner became a hangout for the local teenagers. They stopped by the diner after sporting events or movies to grab a hamburger,

a shake and maybe some blueberry pie and ice cream. There was music echoing from the jukebox, and kids gathered around the pinball machine. It was the magnificence of the 1950s inside the small diner. In addition to Cape Codders making Reno Diner their go-to place, celebrities like Ricardo Montalban also enjoyed the happening place. Joseph Davis's daughter Jane Klimshuck remembered the actor visiting the diner while filming his role in the 1950 film *Mystery Street*, which was shot on the Cape as well as in Boston. "I lived next door to the diner," she said, "and I remember when Ricardo Montalban went to eat at the diner and went to relax and study his script on our front steps. You never forget that sort of thing!"

The diner continued to thrive throughout the 1950s. In 1960, Ross Demetras of Falmouth, who had owned the Column Terrace Hotel, purchased the diner and neighboring cottage. They were leveled and replaced by the Orleans Holiday Motel, which was run by Demetras's wife, Maria. A pancake restaurant was built next door and run by Ross. Eventually, the Orleans Holiday Motel became a Rodeway Inn, which is what stands at the location of the former Reno Diner as of 2016.

The classic diner might be a rarity these days; however, the legend of the Reno Diner, its story and the people who made it special still remain strong to this day.

ROSE'S RESTAURANT

Address: 27 Black Flats Road, Dennis
Years Active: 1946–2000

For the most part, the restaurant construction stories are very similar. A parcel of land is chosen, and a structure is built on it with the intention of it being a restaurant. It is rare, perhaps a unique anomaly, when a parcel of land is purchased with a family home that over time grows to be a restaurant. Even rarer is the fact that this family home turned restaurant would go on to be one of the most celebrated, beloved and influential restaurants ever on Cape Cod.

Family owned and family operated, it was literally a home that became a restaurant yet still felt like home to the countless satisfied customers who walked through the door. It was Rose's Restaurant. Rose's and the Stocchetti family, who ran it, were an institution in Dennis for over half a century.

The story of Rose's began in the Boston suburb of Dorchester. In the 1930s, the family patriarch, Angelo, ran his own auto mechanic shop in Boston's largest neighborhood. However, he and his wife, Rose, had always had an affinity for the little peninsula of Cape Cod. Close friends of the couple had purchased land and built summer cottages on the Cape. The family summered on the Cape before they sold the business in Dorchester and moved to Dennis in 1939.

Upon the Stocchettis' arrival on Cape Cod, the area where the famed restaurant would reside was a much different place. There was only one

home on Black Flats Road; the rest of the land was open. Perhaps sensing that there was to be more happening in Dennis than just a home to raise their family, Rose ended up purchasing much of the property on Black Flats Road, at $100 per lot. It would come in very useful.

The legend of Rose's began with the matriarch doing what she enjoyed doing: cooking. Her sauces bubbling on the stove in the small cottage half a mile from the beach would waft through the neighborhood. It began attracting fans, and Rose graciously fed them. She also had paying boarders at the cottage whom she fed as well. It all came as a surprise to Angelo, who was working as a mechanic for the gas company in Hyannis. The downstairs bedrooms in the family's cottage were rented to boarders, while the family summered upstairs in the unfinished attic. The restaurant that became the first Italian spot on Cape Cod began mainly by circumstance.

Though it did not become official until 1946, Rose's was pleasing customers long before that with delicious homemade Italian cuisine. In the beginning, the menu was quite simple; it consisted of spaghetti and meatballs, Ballantine beer and pizza. This was a new thing on Cape Cod. Rose Stocchetti not only opened the first Italian spot on the Cape, but she also brought pizza as well. It was a square pie with a thin crust topped with cheddar cheese rather than mozzarella. The guesthouse was filled with people wishing to try the delicious new pizza as well as other traditional Italian choices around a long square table. The food was scrumptious, and word spread fast. Before long, Rose's Restaurant was official and in need of expansion.

The first step was adding a patio room with eight booths. But that would not be nearly enough. At its peak, the four-hundred-square-foot guesthouse became a four-thousand-square-foot restaurant with 150 seats, three dining rooms and a lounge. The cottage that served family, boarders and neighbors would go on to serve as many as three hundred patrons a night in its heyday. The extra property on Black Flats Road that had been purchased was put to use as a gift shop and mini-golf course, and four rental cottages were built.

Rose's daughter Sylvia Leonard remembers the expansion being gradual, with the front dining room being the first addition. People came from all over the Cape, from Chatham to Provincetown, to enjoy the lasagna, stuffed shells, veal marsala, shrimp scampi, pork chops, steaks and, of course, Angelo's antipasto salad. No matter how big Rose's got, it still remained first and foremost a family restaurant. There was a large round table located in the front dining room where members of the immediate family could relax and eat.

The family atmosphere extended from that table to each and every customer who entered the establishment. Rose loved children and truly enjoyed meeting the young ones brought in by their parents and grandparents. The matriarch would gleefully whisk the children around for a tour, bring the sleeping babies a blanket and generally make them feel special and appreciated.

Time passed, and things changed. Angelo passed away at the young age of sixty, leaving Rose and her three children in charge of the day-to-day operations. Sylvia's husband, Russell, built a lounge onto Rose's, appropriately named Angelo's Lounge after the patriarch. Even as the years went on, Rose was a fixture at her restaurant. She would sit at the family table, and many guests would come and sit with her and enjoy a cup of coffee and a moment with a great lady. That family table now resides with the Stocchettis' friends at the Mattakeese Wharf Restaurant in Barnstable.

The twenty-first century began, and the family knew it was time. Rose had become ill and could not participate in activities at the restaurant. The children sold the restaurant and adjoining properties only on one condition: that it would not continue as a restaurant. It was more than just a restaurant; it was the Stocchettis' home above all else. Rose's was closed and sold in 2000, ending more than fifty years of Cape Cod's beloved "Little Italy" in Dennis. In its place, a pair of private homes were built.

Sylvia Leonard says she wouldn't change a thing about her life. "It was our home," she said, "where we lived. It was a family restaurant in every sense of the word. It was life."

SOUTHWARD INN

Where the fun is.

Address: 107 Main Street/30 Route 28, Orleans
Years Active: 1916–1962

It began during wartime and changed locations early in its existence. Either of those obstacles could have easily spelled doom for the Southward Inn. However, not only did it survive, but it also thrived during more than four decades in business. It would go on to become the place to be for entertainment in Orleans during the mid-twentieth century.

The story of the Southward Inn began in 1916 and does include a man whose last name is Southward. George Southward purchased property in Orleans owned by Edgar Snow, and he and his wife, Rebecca, created the first Southward Inn on Main Street. The establishment barely had time to get its name out there when the United States entered World War I, in 1917. Two years later, Southward moved his fledgling business to a different location.

At the intersection of present-day Route 28 and Cove Road once stood the Newcomb Lodge. In the early twentieth century, it was built as the home of Alexander Newcomb. He was a well-known businessman in Orleans, holding positions such as bank president, town clerk and selectman for eighteen years. Newcomb was believed to be the first person to own an automobile in the town. Unfortunately, in May 1911, he also became the first person to die in an automobile accident in town. His home was left to

Southward Inn, Orleans. *Courtesy of Orleans Historical Society.*

his adopted daughter Mary, who turned it into the Newcomb Lodge. She sold it to James Eldredge in 1917, and he, in turn, sold it to Southward in February 1919. It was a move of only half a mile, but it took Southward Inn light years from where it began.

Southward Inn was a fully functioning restaurant as well as hotel, picking up steam in popularity in the Roaring Twenties. By the time 1925 rolled around, George Southward was sixty-one years old and looking to reduce his workload. He sold his establishment to Camille Remillard. Unfortunately, that marriage did not last long, and in 1932, Southward Inn was back on the market. With no other offers, George bought back the inn, reassuming management duties.

Southward again relinquished control of his establishment in 1935. Bill and Eve Rich took over and began to push the inn to new heights. Southward's wife, Rebecca, died the next year, and George passed in 1938, closing the book on the original owners.

As the 1930s ended and the 1940s began, business at the Southward Inn continued to grow. The Riches kept the beautiful ambience of the inn with the warm entryway fireplace.

They added the special touch of a loudmouthed parrot that enjoying chatting it up with patrons, a unique sight for a Cape Cod establishment. They employed great chefs like Thomas Garner and Robert Swan, who

enhanced the cuisine, while the liquor business increased throughout the years as well. Items such as the Cape Cod bay scallops, lobster Newburg and codfish with sour cream brought in customers from all over. However, folk artist, entrepreneur and local celebrity Peter Hunt added the finishing touches to the grand masterpiece that was the Southward Inn.

Hunt's furnishing designs gained great acclaim in outlets such as *Life* and *Mademoiselle* magazines. He opened a collection of shops in Provincetown along Commercial Street known as Peasant Village, establishing his style and legend on the Cape during the 1930s and '40s. In 1951 Hunt designed the Carriage Room at Southward Inn. Furnished with antiques, copperware, old photos and coach lamps, it was a perfect capper to the inn. In 1954, Hunt wrote his *Cape Cod Cookbook*, using recipes from Southward Inn and forever preserving its legacy.

It was after the debut of the Carriage Room that the entertainment at Southward Inn really took off. Under the ownership of Frank and Betty Richards, who purchased it in 1952, the Orleans staple began to bring in some of the most noted jazz artists of the decade to perform. Pianist Dick Miller, Leroy "Sam" Parkins and the Excalibur jazz band and others thrilled audiences with their slick style. In addition, square dancing became a craze at Southward Inn, and every Friday night, Fred Moynahan and his orchestra performed for those wishing to show off their dancing skills.

From jazz music to square dancing and the Carriage Room to other unique lounges like the Garden Room, Fisherman's Bar and Terrace Lounge, the Southward Inn had numerous reasons why it was so popular for weddings, private functions and birthdays. Small touches like the chatty parrot or the king and queen playing cards on the restroom doors made this spot unlike any other on the Cape. However, its sale to Delbert Johnson, then owner of the Governor Prence Motor Lodge in North Truro, in 1961 would prove to be the end.

The following year, Southward Inn was rechristened the Nauset Inn. It was not associated with a 1920s establishment in Orleans by the same name. The business continued on into the 1970s, even undergoing another name change, the Head of the Cove. The legendary establishment closed and was torn down in 1977.

As of 2016, a Masonic lodge stands on the site of the original Southward Inn on Main Street; a Bank of America stands at the site of the second Southward Inn on Route 28.

STARBUCK'S

The place is always cooking.

Address: 645 Route 132, Hyannis
Years Active: 1986–2006

Long before a certain Seattle-based coffee giant landed on Cape Cod, Starbuck's was already a household name on the peninsula. Along the busy Route 132 in Hyannis, for two decades a restaurant was creating great food and great memories in a highly unique atmosphere.

In 1986, with two successful restaurants under his belt, Marty Bloom took a chance on opening a new venture. He had already run Fred's Turkey House in West Yarmouth along with his father, Fred, for a few years while still in college in the late 1970s. Bloom then moved on to open his eponymous restaurant, Bloom's Prime Rib House, in West Yarmouth in 1981. His idea for his newest project came from something very familiar.

TGI Friday's, a popular casual American dining restaurant chain that first opened in 1965, became the inspiration for Bloom's new restaurant. He would call it Starbuck's, playing off of the Starbuck family, a prominent whaling family on the island of Nantucket from the seventeenth through the nineteenth centuries. There is also a connection to the iconic book *Moby Dick*, written by Herman Melville, as Captain Ahab's first mate is also named Starbuck. Bloom then chose Route 132 in Hyannis as the location for his new establishment due to the fact that it was one area on Cape Cod that was busy year-round.

Starbuck's in Hyannis at night. *Courtesy of Marty Bloom.*

In 1984, Bloom applied for a liquor license for Starbuck's. It was a fight to get one, as they were not that readily handed out at that time; many more such licenses would become available in the following years.

Next up, Bloom wanted to create a new and distinctive design for his establishment. Items like a large round center bar, neon signs to spice up the atmosphere, oversized wicker chairs and his "bleachwood" (a mixture of paint and stain) helped to form the wildly charming interior of Starbuck's. The design of the restaurant entered and finished second place in the 1986 National Design Competition put on by *Restaurant Design* magazine.

Bloom was a hands-on restaurateur, as he wrote all of the radio ads for the establishment and the creative and somewhat comical menu. It featured items like the Chief Justice Warren Burger Burger; the Larry Bird burger, which was a triple double of mushrooms, Canadian bacon and swiss cheese; the Mexican section, which was called "Ever Since You Met My Sister Molly You've Been Cold to Me and Hot to Molly"; and the soup du jour, "We don't know what it is but we have it every day." All of this made a meal at Starbuck's more than just sitting, eating and leaving.

"I really went for broke with it," Bloom said of the detail and dedication he put in to the entire setup of Starbuck's. Success did not come right away, though. Though the business was okay in the first year, it was driven more

by summer sales and liquor, which made up more the 60 percent of the earnings. Heading into the second year in business, Bloom revamped the menu and created a "cool and casual upscale location." This brought the food sales up, and business took off from there.

By the time Starbuck's was in its third year, it was doing sales of $3.5 to $4 million, amazing numbers for the late 1980s. With Bloom's Prime Rib House still going strong in West Yarmouth, Marty attempted another new venture, called Stromboli's, in 1987. It replaced a Denny's right near the Airport Rotary. It was one of a few unsuccessful attempts at opening a restaurant. Bloom still managed to turn it into a success by rebranding it Champions Sports Bar. This was popular with customers, but not with the town, so it was closed and became a Pizzeria Uno.

After selling Bloom's in 1992 and venturing off-Cape to create his successful chain of Vinny Testa's Italian restaurants in 1993, it became increasingly difficult for Marty to put his energy into Starbuck's. His mother and sister helped keep it going through the 1990s. He tried to reinvent the location as Star City Grill as the twenty-first century began, but the change proved to be a mistake. The ever-popular Starbuck's closed in 2006, leaving a twenty-year legacy of fun in the mid-Cape area.

Bloom says that one of the lasting memories for him of Starbuck's is just how many people met their significant others there during its time in business. A Circuit City megastore was meant to open in the location in 2009, but the company went bankrupt. As of 2016, a Harbor Freight Tools sits on the spot where Starbuck's once stood.

SULLIVAN'S DONUT SHOP

The last of the Irish doughnut makers.

Address: 489 Bearse's Way, Hyannis
Years Active: 1975–1993

Sullivan's was a staple of downtown Hyannis for two decades in the times before Dunkin' Donuts resided on nearly every street corner on Cape Cod. After successfully running three other doughnut shops in Brockton in the 1950s and '60s, John "Sully" Sullivan was making doughnuts at a Dunkin' Donuts in Stoughton, Massachusetts, in 1971, when he was hired by a shop called Sugar N' Spice in South Yarmouth. The unofficial mayor of Brockton moved his wife, Rosemarie, and their five children to the mid-Cape area. There he hoped to settle into a quieter routine, escaping the busier and sometimes dangerous streets of Brockton in the early 1970s.

Not too long after Sullivan left Sugar N' Spice, he worked at a Dunkin' Donuts on the corner of Forest Road and Route 28 in South Yarmouth that still stands as of 2016. Doughnut making was a passion of Sully's; it also ran in the family. Sullivan's father, also named John Sullivan, had run a doughnut shop in Hampton Beach, New Hampshire, before World War II. It was not long before Sullivan's Donut Shop lived again, this time on the corner of Bearse's Way and Route 28 in Hyannis. The new shop opened in late 1975 and gained popularity from the get-go.

These doughnuts were made the old-fashioned way in large vats of oil, with bakers using sticks to flip the sweet lumps of dough and make sure they

were properly cooked on each side. These doughnuts were heavier and more filling and satisfying. They came in all sorts of delicious shapes and sizes. There were classic honey-dipped, chocolate frosted and jelly-filled; there were crullers, coffee rolls and doughnut holes. There were also delectable muffins and coffee, of course.

Though it opened very early for people on their way to work, some could not wait until sunrise for a fresh and hot doughnut. Sully would open his back door before officially opening for the day and sell doughnuts to customers. This practice has been made well known thanks to Back Door Donuts, located in Oak Bluffs on Martha's Vineyard. This is part of the Martha's Vineyard Gourmet Café & Bakery, which opened in 2001.

However, there was much more than just a run-of-the-mill doughnut shop lying in those four walls. Sullivan's was a meeting place before there was Starbucks, and it was every bit a family-run business. Sully's wife, sons and daughters all worked hard to make each and every customer feel welcome. In return, the customers made Sullivan's a destination. There were also times when the customers were the staff. A handful of regulars knew how to open the shop, and once the doors were unlocked, they would happily help with the setup, pulling down stools and starting the coffee.

There were several unique touches to Sullivan's that made it more than just coffee and doughnuts. For starters, there was a piano located in the corner of the shop; no other Cape Cod doughnut shop could lay claim to that. Said piano would be played daily by the house piano player, Barnstable High School English teacher Ed Milk. It was also played by legendary jazz pianist Dave McKenna. Considered to be one of the finest pianists in the world during his career, McKenna, also a neighbor of Sully's, would often play music to the delight of customers and to pay for his doughnuts.

After moving to Cape Cod in 1966, McKenna played many shows at local bars and nightclubs. Sully remarked that he would often go into work at the doughnut shop at 1:00 a.m. This was around the time that most of the local bars would close, and the musicians, including McKenna, who had been playing would come knocking on the door looking for something to eat. Legend has it that McKenna once ate eighteen hot honey-dipped doughnuts in one sitting but stopped there, telling Sully he "didn't want to seem like a pig."

Also unique to Sullivan's was the meticulous, hand-painted mural of the mid-Cape area on the wall of the shop. It was common for customers to walk over to the mural, coffee or doughnut in hand, and stare in wonder at the painstaking detail put into this piece of art.

Sullivan's popularity stretched beyond the average joes who stopped in before work. Legendary Boston Bruins announcer Fred Cusick enjoyed popping in for a visit when he was around during the 1970s and '80s.

Longtime Kennedy chauffeur Tommy Roderick also frequented the donut shop, picking up a box because "Jackie loved blueberry muffins." So popular was Sullivan's that Barnstable Police remarked to Sully that if they were ever looking for a suspect in Hyannis they would simply stake out Sullivan's and neighboring Christy's because whomever they were looking for would end up there eventually.

Sullivan's thrived into the 1990s, when construction at the plaza where it resided caused the shop to be closed for a while. It had been featured on the corner of the plaza with glass windows facing the traffic; now it had been pushed inside to a smaller location. Unfortunately, business suffered, and Sullivan's closed early in 1993.

Much of the equipment used to make the doughnuts at Sullivan's was bought by the Hole In One Donut Shop. This company, run by four sisters, continues to make doughnuts the old-fashioned way to this day, even in a world filled with Dunkin' Donuts and Krispy Kreme. They are still going strong as of 2016, with locations in Eastham and Orleans.

As of this writing, a convenience store sits where Sullivan's once resided.

THE SWORD AND SHIELD RESTAURANT

Address: 554 Route 28, Harwich
Years Active: 1968–1990

There are some places that do not need any sort of advertising to become popular. Great food and a great atmosphere coupled with a great staff lead to great reviews, which lead to increased business. Such is the case of the Sword and Shield Restaurant in Harwich. It was here along Route 28 that a legendary establishment was created by an even more legendary person.

Ted Apostol had known he was going to become involved in the restaurant business from his time stationed overseas in World War II. It was during his five years in the service that he began working in the kitchen, cooking en masse and serving his commanding officers like General George S. Patton. Apostol fought for the United States at Normandy, France, on D-day in 1944; he was already a hero and a legend before even stepping foot in a kitchen on Cape Cod.

Upon returning home, Apostol married his sweetheart, Denise. Her family was also entrenched in the Cape Cod restaurant scene; an uncle owned the Riverway in Yarmouth, and a cousin owned Stageway in Dennis. Ted worked for Nicholas Vroundgos, who ran the New Yorker Restaurant on Route 28 in Harwich Port. The spot already had a lengthy history, having been opened as the New Yorker Sandwich Shop by Vroundgos and Arthur Draine in 1932. Ted worked there before he went off to war and returned after showing the loyalty and work ethic that would define him and rub off on his staff.

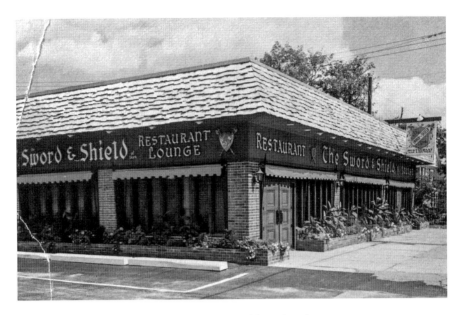

A Sword & Shield Restaurant postcard. *Courtesy of Stacy Apostol.*

Ted and Denise bought the New Yorker from Vroundgos in 1948 and began their dream of running a restaurant. It started slowly, with little changes being made to the restaurant as the couple got their feet under them as management. It would not be very long until the establishment was transformed from sandwich shop to full-blown restaurant.

The New Yorker was seasonal at first, closing for the winter; however, the Apostols would stay open year-round once they received a liquor license, in 1966. Despite being of Greek heritage, Ted chose not to feature his native cuisine as part of his restaurant, choosing instead to stay true to the original menu of American-style and English-style items. Welsh rarebit, prime rib, clam chowder, Virginia baked ham, a fisherman's platter, stuffed lobster and swordfish dishes were all faithfully prepared for decades. The only thing the Apostols added were their wildly popular sweetbreads.

Into the 1950s and '60s, business grew. The New Yorker eventually had a staff of fifty during the busy season. At one point, Denise was having trouble signing the checks for all of the staff, and she asked Ted to go down to the courthouse and have his last name changed legally to Apostol from its original spelling of "Apostolopoulos." The biggest change for Ted was still yet to come.

In 1966, the New Yorker was closed and completely remodeled. Inside, the décor would be a throwback to sixteenth-century England, with plaid-

colored carpeting, new outdoor awnings supported by knightly spears and an entrance canopy. By May 1967, the remodeling had been completed, and the little sandwich shop was now nearly four times its original size. It was rechristened the New Sword and Shield of York, though most would simply call it the Sword and Shield.

The grand reopening was highly covered, including a mention in the *Boston Globe*. This was the only time in their entire tenure of ownership that the Apostols would spend any money on advertising. The rest was all word of mouth. At one point, Denise remarked that she estimated 85 percent of their customers were repeat; she could recognize hundreds of people by their faces.

The Sword and Shield continued to expand in 1969, with the addition of the Merrie Knight Pub, which featured light fare, a full stock of liquor, a walnut bar and red and black plaid carpeting. With the addition of this lounge, the Sword and Shield was able to seat up to 350 people. There would routinely be lines of people out the door waiting to get in from 6:00 to 9:00 p.m. nearly every night during the summer.

Such a booming business depended on great management and a great staff. Ted and Denise made sure to take care of both. Many of the staff they would hire in the early days as the New Yorker remained with them for twenty years or more. They were and still are a tightly knit bunch. Several people who got their starts under the Apostols at the Sword and Shield learned the business under Ted and went off to start their own restaurants.

Ted Apostol became a legend due to things like cooking meals for locals at his establishment during blizzards when people would lose power, as he had a generator. It was also his very close friendship with Speaker of the House "Tip" O'Neill, who was a frequent visitor, that got his name noticed in the Washington, D.C., circles.

In 1984, the Apostols sold their iconic establishment to Wychmere Beach Club chef George Sherman. He immediately changed it up by advertising the Sword and Shield in local newspapers. Sherman ran the restaurant for a few years before selling the property to Dr. J. Richard Fennell early in 1990.

Even after leaving the restaurant business, Ted Apostol remained vibrant and active, even picking up golf at the age of eighty. He lived a long, full life, passing away at the age of ninety-nine in 2015. Denise currently lives in San Diego with her daughter Stacy, who was an active part of the business, working the bar or waitressing. Their legacy is defined by their work ethic and a dedication to simple good food that made the Sword and Shield a spot that is still remembered fondly more than two decades after closing.

As of 2016, three businesses—Buckies Biscotti, Cranberry Jewelers and the Mad Minnow Restaurant—now stand where the landmark restaurant once did.

THOMPSON'S CLAM BAR

Address: Snow Inn Road, Harwich Port
Years Active: 1950–1997

Hey! Where ya going?!" Chances are if someone grew up on or visited Cape Cod at any time from the 1950s through the 1990s, they know the answer to this famous question.

There are few restaurants to ever exist on Cape Cod to match the instant recognition of Thompson's Clam Bar. Even those who might have never partaken in some of the celebrated fried seafood knew of the immense reputation of this establishment as the champion of the Cape's seasonal restaurants.

Along the spectacular Wychmere Harbor in Harwich, the only thing that equaled the food was the atmosphere at Thompson's. Situated on the western side of the entrance to Wychmere Harbor, it was possible to take a seat right along the water and watch the myriad vessels passing in and out. The boats cruising by on a warm summer evening with a basket of fried clams in front of you is a postcard for a perfect Cape Cod experience. This is the reason why Thompson's did astronomical business during its time in existence.

Thompson's was founded in 1950 by three brothers: Frank, Biddle and Edric Thompson. During its more than four decades in service, the restaurant became an institution. It was, at one point, the largest seasonal restaurant east of the Mississippi River.

From the time the 552-seat restaurant opened in mid-June through the time it closed in mid-September, it was possible to serve more than two thousand people in one night several times during the season. Some of those customers would wait for a table for up to an hour and a half just to get their fix of what Thompson's had to offer.

The drive down Snow Inn Road was filled with anticipation knowing what lay along the water. Cars would slow down to be greeted by valets to take the guesswork out of parking. It was not uncommon for the parade of customers waiting to get their cars parked to stretch all the way from the Thompson's parking lot out to Route 28, just over a quarter mile.

The legendary shack that housed the clam bar was originally part of an eight-room inn built on the western side of what was then Salt Water Pond. It did not become a harbor until it was successfully dredged in 1889. The three Thompson brothers' parents had been married at the inn in 1913 and stuck around to run it. The brothers started out living in the future restaurant as a home, which they referred to as Hangover Inn, or alternately, Spit 'n' Whittle. The Thompson family eventually allowed fishermen to tie their boats at the docks alongside the inn and unload their catch. People saw the activity along the water and began asking to buy seafood literally right off the boat. This led to people wanting their freshly bought catch to be cooked or opened right there, and after a while, the family turned the boys' home along the docks into Thompson's Clam Bar. The rest, as they say, is history.

Though it started off as a haven for guests of the neighboring Snow Inn, Thompson's soon became more than a popular spot for lunch or dinner—it became a landmark and a place to be seen. Politicians like Senator Ted Kennedy and Speaker of the House Tip O'Neill were routinely spotted there, and legends like New York Yankee Joe DiMaggio had to stop by and see what all of the fuss was about. Whether it was the celebrated fried clams or clam chowder; baked, broiled or lazy lobster; classic seafood such as scallops and shrimp; fresh fish like scrod, sole or bluefish; and all the way to chicken and steak, Thompson's had something for everyone. The variety was just one of the many reasons it became the top spot on any Cape Cod bucket list for four decades. It would grow so large, in fact, that a second Thompson's opened for a time in North Truro in the 1960s.

Thompson's was such a monster on Cape Cod that even its staff dormitory, the Bourne House, which was located near the entrance of Saquatucket Harbor, garnered a legacy in its own right. It was purchased in 1976 by Robert Brackett and became known as Brax Landing—going strong for four decades.

In 1982, J. Richard Fennell purchased the iconic spot from the Thompson family after the three Thompson brothers had passed and running such a large establishment became too much for their widows. He continued to proudly keep the tradition alive. In 1984, he had some renovations done on the iconic structure, placed fender pilings along the waterway face of the building, replaced the deck and fixed up the roof. He attempted to expand on the Thompson's name by creating Thompson's Farm Market in 1989 on Route 28 in Harwich across from Brax Landing. The restaurant itself would continue to grow, with the Captain's Bar and an upstairs Victorian lounge. The lounge was renamed the Harbor Watch Room in 1991 after a long legal battle with the town.

Thompson's lasted well into the 1990s, winning Best Waterfront Dining and Best Seafood Restaurant on the Mid-Cape from the readers of *Cape Cod Life* magazine in 1995. It became part of the newly established Wychmere Harbor Beach and Tennis Club in 1996. The building remained open and was used for private parties in conjunction with the club. Fennell attempted to keep the flame burning by turning his Harwich Port establishment, Nick and Dick's, into Cap'n Thompson's Clam Boat on Route 28. Despite it only lasting two seasons, it did take home Best Outdoor Restaurant on the Mid-Cape through *Cape Cod Life* in 1996—a fitting tribute to just how strong the call of the Thompson's name was.

The memories of Thompson's remain to this day, with a DVD depicting a day in the life at Thompson's from 1983 for sale through the Harwich Historical Society. What about the iconic jingle that tickled Cape Codders and visitors' ears on the radio for decades? It was purchased by Eastham restaurant Arnold's Clam Bar and repackaged in 2011. Thompson's Clam Bar still remains deep in the fabric of Cape Cod twenty years after its closing.

As of 2016, the Wychmere Beach Club stands where the famed clam bar once stood along the water in Harwich.

TIP FOR TOPS'N

Specialties from the Sea

Address: 31 Bradford Street, Provincetown
Years Active: early 1950s–2013

I n a historic town filled with legendary establishments and shops, this one
ranked near the "tops'n" for decades. Provincetown's history is rich with
Portuguese heritage. In the latter part of the nineteenth century, sailors from
the Azores were brought on to become part of the area's whaling fleet. They
brought along their culture and cuisine, which began to dominate the tip
of the Cape. Today, there is still a strong connection in Provincetown to
Portugal, including the yearly Portuguese Festival, which occurs in June.

One celebrated Portuguese name in Provincetown was that of the
Carreiros. It began with Ernest L. Carreiro, who was a native of Sao Miguel
in the Azores. He came to America just after World War I and moved to New
Bedford. Ernest moved to Provincetown in 1930, got married and eventually
opened Anybody's Market on Bradford Street. The market was turned into
a restaurant in the early 1950s. It was called Tip for Tops'n, from the tag line
"Tip of the Cape for Tops in Service."

The new establishment was a hit, featuring ties to the fishing and whaling
history of Provincetown with its nautical décor inside. Ernest Carreiro
also remained true to his Portuguese heritage by serving ample portions
of authentic cuisine. However, Tip for Tops'n's chance at legendary Cape
status was almost cut short when Ernest passed away in 1961 at age fifty-

three after being ill for several years. The business was taken over by his son Ernest L. Carreiro Jr. for a few years before being purchased by another Carreiro, Edward, in 1966.

Edward, nicknamed "Babe" had come to Provincetown, also by way of New Bedford, in 1947. After serving in the army in World War II, Edward became a fisherman, purchasing a fishing boat in 1963 that he christened the *Jenny B*.

Edward and his wife, Eva, stayed true to the original Tip for Tops'n design, combining friendly service with ample portions of Portuguese cuisine at breakfast, lunch and dinner. Linguica was a definite for any meal of the day. In addition to sandwiches at lunch, Tip for Tops'n served items such as clam chowder, kale soup and Portuguese-style mussels. Dinner featured heartier native specialties, including Peixe Assado, a baked stuffed sole with sea clam stuffing; Cavala em Molho Cru, fried mackerel; a Portuguese bouillabaisse served with saffron rice called Caldeirada de Peixe; and a spicy version of pork with clams. The desserts were quite popular as well, despite the large portions. Items such as the warm bread pudding with ice cream would often be found making their way to satisfied patrons' tables before the check.

Tip for Tops'n placemat, 1962. *Courtesy of Salvador Vasques.*

It could only seat fifty-seven people at a time in its booths and tables, which meant that the small restaurant was packed most of the time. But the qualified staff helped keep things moving without making customers feel rushed. Slightly off the main route of Commercial Street, Tip for Tops'n managed to keep pace with the larger establishments by staying true to keeping things simple, fresh and authentic. It was a haven for local year-rounders.

The Carreiros continued to successfully run Tip for Tops'n into the twenty-first century. Edward and Eva semi-retired, and the business was largely taken over by their sons Jerry and Joey and their daughter-in-law Joyce. They kept the legendary eatery rolling into its sixth decade. Sadly, Edward was not there to see Tip for Tops'n reach its seventh, as he passed away in 2008. The family suffered another tragic loss when Jerry suddenly passed in 2009. Joey and Joyce kept the business alive and kicking for a few more years, but eventually, they decided the time was right to sell.

In 2013, a new place opened up on the spot at 31 Bradford Street called Devon's, run by Devon Ruesch. He largely kept the design and décor from Tip for Tops'n intact. It is still open as of 2016.

Tip for Tops'n may now be only a memory, but the Carreiro family successfully wove themselves into the magnificent tapestry that is the culture of Provincetown. That legacy will carry on for many more years to come.

THE YANKEE CLIPPER

Address: 131 Route 6A, Sandwich
Years Active: 1932–1985

It started when the town of Sandwich was only home to 1,400 people, during the early days of the Great Depression. It lasted through that hard time, three wars and ten different presidents of the United States. It was one part seasonal restaurant and one part village pub. It was the iconic Yankee Clipper Restaurant on Route 6A.

The Yankee Clipper, named after the fast clipper sailing ships that became popular during the mid-nineteenth century, started as the brainchild of Sandwich resident Jack Bazzinotti in 1932. The location chosen to house this new venture was no accident, either. The corner of Route 6A and Jarves Street in Sandwich was home to several other enterprises run by the Bazzinotti family. The family owned a gas station and a convenience store in the immediate area at the time.

Jack Bazzinotti ran the Yankee Clipper as a seasonal establishment priding itself on fresh fish, lobster, chicken and seafood. The restaurant's reputation garnered it some accolades, as it would be recognized as a fine eatery by the people at Duncan Hines and *Gourmet* magazine.

Meanwhile, off Cape a young Bob Gianferante was plying his trade in the restaurant business fresh out of college. Bob worked for the Sheraton, Red Coach Grill in Hingham and White Cliffs Country Club in Plymouth. As luck would have hit, he bumped into Jack Bazzinotti's brother, who

Yankee Clipper Restaurant, Sandwich. *Courtesy of Rose and Bob Gianferante.*

informed Bob in 1964 that Jack was looking to sell the Yankee Clipper. Wanting to run his own place, Bob made an offer and became owner.

In a high-class move, on assuming the ownership of the Yankee Clipper, Bob kept on most of the staff who had worked under Jack and fleshed out the rest of the employees from the local population to help keep the small-town vibe of the restaurant. There were no immediate grand changes to the restaurant when Bob and his wife, Rose, took over. The menu changed a little, but the décor inside stayed very much intact. There were two dining rooms, which helped the establishment seat up to 160 people at a time. One dining room had hard pine floors, and the other had a maple floor. Gianferante refinished the floor during the off season, and it gave off such a beautiful shine that customers would often ask if they were even allowed to walk on it. There were nautical paintings on the walls, high-back booths and a bar. The large seating capacity meant that most times it was possible to find a table, with minimal wait time.

From Memorial Day to Columbus Day the people came. They enjoyed the fresh, authentic seafood often brought in that day from fishermen out in Cape Cod Bay. According to Bob, the most beloved menu item might have been their roast duck. The secret? It was using ducks raised nearby on the famed Walter H. Mayo Duck Farm in Orleans. Located on the way to Nauset Beach, this farm hatched as many as one thousand ducklings

per year. Fresh duck was a big drawing card. When Mayo's farm closed, Gianferante chose a farm on Long Island to get his ducks, but the item's popularity did not wane.

One unique aspect to the Yankee Clipper was the fact that even though it was a seasonal restaurant, it was a year-round establishment. When the main restaurant closed Columbus Day weekend, Gianferante's locale went from a jumping hot spot of lunches and dinners to a village pub. There was a simpler, pared-down menu featuring hamburgers, hot dogs, chowder and, of course, liquor. It became a spot for locals to hang out during the long and, at times, excruciating winter.

As time went on and the population of the town grew, it only made business better for Bob and Rose. They still knew most customers by face when they came in. The Canal Generating Plant opened in 1968 and brought more jobs and people to the area. Naturally, many of the local fishermen stopped in to eat, not just sell their catch. All in all, it remained a "local place in a lovely town," as Bob wistfully recalled.

In 1985, after more than twenty years in the business and putting in more sixteen- and eighteen-hour days than he cared to remember, Bob knew it was time to leave the restaurant behind. Much the same way as he had originally heard about the restaurant's sale, it was a customer who informed Bob that his girlfriend was looking to buy a place. An offer was made, and during the offseason, the Yankee Clipper was sold quietly. It reopened as the Bare Tree Inn.

Bob Gianferante tried his hand at construction before retiring, while Rose began working in real estate. The couple still lives on Cape Cod to this day and has fond memories of watching their "interesting little town" grow over the years. As of 2016, the Sandwich Antiques Center resides in the building where the Yankee Clipper stood for fifty-three years.

RECIPES

For those whose thirst for memories of the legendary lost restaurants of Cape Cod has not been quenched yet, there is a special bonus. Thanks to the help of the wonderful people at Cape Cod Life Publications, I am proud to share with you some authentic recipes from some of those restaurants featured in this book. These recipes come straight from the archives of *Cape Cod Life* magazine. Now you can re-create the tastes of some of your favorites at home. Please enjoy!

CHEESE SPREAD

The Dome Restaurant

2 pounds Cooper cheese (substitute any sharp, natural Cheddar cheese that is
 well aged)
2 pounds Neufchâtel
½ teaspoon granulated garlic
½ teaspoon salt
1 dash of Tabasco
Yellow food coloring

A Dome Restaurant postcard. *Courtesy of Falmouth Historical Society.*

Chop the Cheddar cheese and grind it in a food grinder. Stir in the Neufchâtel and add the seasonings to taste. Add coloring.

Note: This is to be made in large batches and frozen for convenience; before serving, bring to room temperature.

.

GAZPACHO

East Bay Lodge

2 ½ cups California tomato juice

1 ½ cups peeled and chopped tomatoes

2 teaspoons wine vinegar

2 tablespoons fresh lemon juice

½ teaspoon Worcestershire sauce

2 cloves garlic, crushed
Salt and freshly ground whole pepper
½ white onion, diced
1 cucumber, peeled and diced
½ green pepper, remove seeds and dice
Parsley, chopped and whole sprigs

Place all items except onion, cucumber, pepper and parsley into a blender and puree. Put into a container and chill 1 hour. Whip prior to serving and serve in bowl in crushed-ice holder. Garnish top of the soup with onion, cucumber, pepper and chopped parsley. If desired, place one sprig of fresh parsley in center. Serves 4.

Note: A chilled soup ideal for warm summer days. This cold soup should be served with a chilled Spanish sangria.

.

DOUBLE SHOT RUM PIE

Christopher Ryder House Restaurant

3 eggs, separated
⅓ cup sugar
¼ cup water
1 tablespoon gelatin
1 cup heavy cream
Whipped cream
4 tablespoons dark rum (light rum may be substituted)
1 pie shell, baked
Curled shavings of sweet chocolate

In the top of a double boiler, beat 3 egg yolks and sugar until mixture is thick and pale in color. Soften gelatin in the ¼ cup water and add to the egg mixture, stirring constantly until the cream is smooth. Stir cream over cracked ice until it is cool

Christopher Ryder House placemat. *Courtesy of Johnson & Wales University.*

and begins to set; fold in 3 egg whites stiffly beaten, heavy cream, whipped cream and dark rum. Turn the mixture into baked pie shell. Decorate with whipped cream, sprinkle it with curled shavings of sweet chocolate. Makes 1 pie.

.

OYSTERS MOSCOW

East Bay Lodge

6 fresh oysters, shucked
1 pound sour cream
2 tablespoons fresh horseradish
1 pinch dry mustard
1 pinch salt
1 pinch white pepper

142

½ teaspoon Worcestershire sauce
Crushed ice
Black lumpfish caviar
Parsley, washed, dried and finely chopped

Combine all of the ingredients in a bowl, except caviar, parsley and ice. On a 10-inch round plate, place a bed of crushed ice. Open the oysters and rinse them thoroughly. Place them around the outer edge of the plate. With a spoon, place the sour cream mixture over the entire oyster. Using a small cocktail fork, sprinkle caviar over mixture, leaving some of the mixture showing. For the finishing touch, sprinkle chopped parsley very lightly over the caviar.

.

SHRIMP SOUFFLÉ BRETONNE

Asa Bearse House

12 ounces heavy cream
6 ounces scallops
2 scallions, chopped
1 pound butterfly shrimp (about 15)
Touch of cayenne
Salt, to taste
Pepper, to taste
4 ounces Newburg sauce
2 ounces Parmesan cheese, grated

To make mousseline: Blend at the highest speed the cream (at bottom of blender), scallops, scallions, 3 chopped shrimp, cayenne, salt and pepper and 1 ounce Newburg for color. A very thick shake texture should develop. Add more cream if necessary to blend.

Cover bottom of baking dish with remaining Newburg. Line 12 remaining shrimp bottoms up. With pastry bag and star tube (medium size) stuff shrimp with mousseline. Sprinkle top with grated parmesan cheese. Bake at 475 degrees until golden brown, about 15 to 20 minutes. Check bottoms of shrimp to see if they are cooked. Serves 4.

.

SAUTÉ OF VEAL CINDERELLA

East Bay Lodge

Sauce choron
2 egg yolks
1/8 cup of milk
Pinch of salt and pepper
Cooking oil
⅛ cup of flour
4 (4-ounce) veal cutlets pounded thin
Seasoned bread crumbs (enough for 4 cutlets)
8 artichoke bottoms
12 jumbo shrimp, cooked, peeled and de-veined
Parsley

Sauce choron: Before cooking cutlets make choron sauce, which is béarnaise sauce with a little bit of very red tomato puree blended through to turn the sauce pinkish orange. Any blend or personal béarnaise sauce is acceptable.

Make an egg wash with eggs, milk, salt and pepper. Bring large sauté pan up to medium high heat and coat bottom of pan with cooking oil. Do not sauté in butter, as veal will burn. Flour each cutlet and dip into egg wash, then seasoned bread crumbs. Quickly pan sauté each cutlet to almost done. Place artichoke bottoms and jumbo shrimp into hot water to heat. Arrange cutlet with 2 jumbo shrimp and 2 artichokes on each.

Cut each shrimp in half length-wise, and shingle 4 pieces on each cutlet. Place each cutlet in oven with their garnishes and bake for 5 minutes at 375. Prior to serving, place a ribbon of sauce over each serving. Garnish with a sprig of parsley. Serves 4.

.

APFELKUCHEN

Inn of the Golden Ox

Filling:
½ cup raisins
¼ cup dark rum
½ cup fresh white bread crumbs
6 Granny Smith apples, peeled and sliced

Pastry:
2 cups all-purpose flour
⅓ pound unsalted butter, softened
2 tablespoons sugar
4 egg yolks

Custard:
2 eggs
2 egg yolks
⅓ cup sugar
1¾ cups heavy cream
Reserved rum

Topping:
⅓ cup sugar
⅓ cup flour
⅓ cup butter
⅓ cup almond paste

Place raisins and rum in small bowl; let stand for 20 minutes. Preheat oven to 325.

In a bowl, combine flour, butter and sugar with egg yolks. When evenly incorporated, line the bottom and sides of an 8-inch spring mold. Fill pastry shell in following fashion: spread bread crumbs over bottom of shell; place sliced apples over bread crumbs. Drain the raisins (reserve rum) and sprinkle them over the apples. Bake shell and filling for 10 minutes in 325-degree oven.

Combine all 5 custard ingredients and fill pastry shell after 10 minutes in oven. Return to oven and bake for 30 minutes or until custard is set. Rub all 4 toppings ingredients together with hands until they flake and form small balls. When custard is set, turn oven up to 425. Sprinkle topping over tart and return to oven until golden brown.

.

POULET POCHE AUX AROMATES

The Paddock

1 large onion
2 stalks celery
2 large carrots
2 large parsnips
1 small turnip
1 pound sliced mushrooms
1 cup cauliflower
1 cup broccoli
½ cup pimentos, diced small
½ cup chopped parsley
3 teaspoons tarragon
2 teaspoons bay leaf
½ teaspoon thyme
½ teaspoon rosemary
½ teaspoon sweet basil

4 (8-ounce) boneless, skinless chicken breasts cut in half, length-wise
4 cups white wine
4 cups chicken broth, heated

Cut onion, celery, carrots, parsnips and turnip julienne style. Place all vegetables, spices and the chicken into a 6- to 8-quart pot. Add wine and hot chicken broth and cover. Put on high heat and bring to a boil. Then reduce heat to a slow simmer for 25 to 30 minutes. Present entrée in the pot, uncovered at the table. Serve it in large soup bowls. Serves 4.

.

SWEET CAPE CRAB CAKES WITH RAMP LEEK VINAIGRETTE

The Regatta of Cotuit

Vinaigrette:
4 ramps (wild leeks; substitute Vidalia onion if necessary)
1 cup extra virgin olive oil
1 tablespoon Dijon mustard
Juice of 1 medium lemon
2 tablespoons champagne vinegar
1 cup extra virgin olive oil

Crab Cakes:
2 pounds lump crabmeat
2 eggs
⅛ cup Dijon mustard
1 teaspoon Old Bay seasoning
¾ cup panko bread crumbs
¼ cup mayonnaise
Juice of 1 medium lemon
Splash of Worcestershire sauce
Splash of Tabasco sauce
1 tablespoon chopped chives
Salt and freshly ground pepper to taste

Lightly brush ramps with olive oil and grill until tender. In a blender, combine grilled ramps with mustard, lemon juice and vinegar. With blender running, slowly add in olive oil.

Drain any excess liquid from crabmeat and mix all ingredients together. Refrigerate for an hour before molding. Using small ice cream scoop, shape 2-ounce portions and sear in hot oil for a minute on each side or until golden brown. To serve, spoon a small amount of ramp vinaigrette over the cakes.

.

Fresh Poached Salmon with Egg Sauce

The Flume

Egg Sauce:
3 tablespoons margarine
2 tablespoons flour
1 cup warm milk
¼ teaspoon salt
¼ teaspoon white pepper
2 hard-boiled eggs, coarsely chopped

Poached Salmon:
4–5 cups water
3 bay leaves
1 tablespoon vinegar
2 teaspoons salt
½ cup dry white wine
6 (6- to 8-ounce) salmon filets
1 tablespoon fresh chopped parsley
Lemon wedges

Melt margarine over low heat, add flour and blend. Cook until mixture begins to look like cornmeal. Add milk slowly while stirring with wire whisk. Cook and stir until sauce is

thick and smooth like heavy cream. Prepare sauce and set aside in double boiler to keep warm while preparing salmon. Add chopped eggs just before serving.

Combine water, bay leaves, vinegar and salt. Simmer together in large skillet. Add wine and filets; continue simmering until fish is firm to the touch. Do not overcook. Remove filets, let drain, place on heated plates and serve egg sauce on outer third of fish. Garnish with chopped parsley and lemon wedge. Serves 6.

.

DUCK LIVER PÂTÉ

Inn of the Golden Ox

2 pounds duck liver
4 cups milk
¼ cup brandy
2 teaspoons kosher salt
1 teaspoon fresh black pepper
½ teaspoon marjoram
4 ounces fatback, diced
6 eggs
½ cup heavy cream
⅓ cup flour
1 pound uncooked bacon slices

Soak liver for 72 hours in 4 cups milk; clean. In a food processor, puree liver with brandy, salt, pepper, marjoram and fatback. When all ingredients are fully incorporated, force liver through a fine sieve, adding alternately eggs, cream and flour. Line a loaf pan with bacon so that the bottom and sides are covered and enough bacon remains to fold over the liquid pâté mix. Fill with mix.

Place the load pan in a larger pan and fill the latter with water halfway up the side of the loaf. This is called a water

bath. The pâté will be baked in this fashion covered with foil for one hour at 325, or until the pâté sets. After it comes out of the oven, weigh down the top and let chill. When chilled, unmold, slice and serve with mustard sauce.

Mustard Sauce:
½ cup mayonnaise
3 tablespoons Grey Poupon mustard
1 teaspoon chopped shallots
1 teaspoon chopped parsley
½ teaspoon chopped garlic
¼ teaspoon fresh ground pepper

Combine all ingredients and chill.

.

INDIAN PUDDING

The Flume

4 cups milk
⅓ cup cornmeal
¾ cup molasses
1 teaspoon salt
1 teaspoon ginger
3 tablespoons sugar
2 eggs

Scald milk in double boiler over medium heat. Add cornmeal and cook for 15 minutes. Stir in molasses and cook for 5 minutes. Beat together salt, ginger, sugar and eggs. Add to mixture and continue to cook over low flame for 1 to 1½ hours, stirring occasionally until pudding starts to thicken. Pudding will have consistency of oatmeal when done. Serve warm with vanilla ice cream. Refrigerate any leftovers. Pudding can be reheated in a double boiler or microwave. Serves 6 to 8.

· · · · · · · · · · · · · · · · · · ·

ROASTED BUTTERNUT SQUASH SOUP

The Regatta of Cotuit

Olive oil
1 medium Spanish onion, chopped
3 stalks celery, sliced thin
2 Anaheim peppers, chopped
4 cloves garlic, crushed
5 pounds butternut squash, peeled, seeded and chopped
1 cup dry white wine
2 cups chicken stock
1 quart heavy cream
2–3 ounces maple syrup
Salt and pepper to taste
Juice of 2–3 limes
1 teaspoon ground cardamom
1 cup crème fraiche (or 1 cup sour cream combined with a dash of buttermilk)
Chives, chopped

Place a roasting pan in an oven preheated to 425 degrees with 2 ounces of olive oil. When the oil is hot, add the onion, celery, pepper and garlic. Let these vegetables sweat for 1 minute and then add the squash. Cook approximately 30 minutes, stirring occasionally until soft and lightly browned. Deglaze the pan with the wine and let the liquid reduce to ⅔ to ¾. When most of the wine is gone, add the chicken stock. Cook for half an hour. Remove the pan from the oven. Puree the soup using a blender. Place puree in a sauce pot on the stove, add the heavy cream and bring to a slow boil. As the soup thickens, add maple syrup, salt and pepper to taste. Keep warm until serving. Juice 2 to 3 limes into a mixing bowl and add cardamom. Mix in slowly crème fraiche, fresh pepper and chopped chives. Place a spoonful of this mixture in the center of each bowl of soup.

NOTES

All of the facts and information in this book were gathered through countless hours of research using newspaper and magazine archives along with personal interviews with numerous former owners, employees and patrons of the restaurants included.

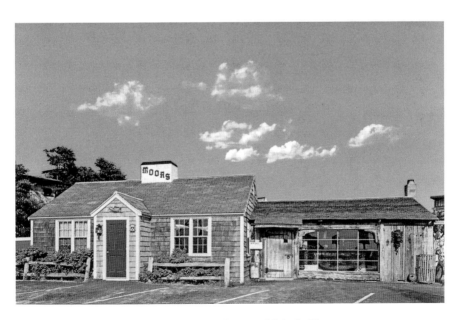

The rebuilt Moors Restaurant after the fire. *Courtesy of Salvador Vasques.*

BIBLIOGRAPHY

BOOKS

McKeag, Donald P. *Well, At Least I Owned a Rolls Royce*. N.p.: DPM Publishing, n.d.

ARTICLES

Anthony, Amy. "At the Paddock, the Tables Have Turned." *Cape Cod Times*, January 15, 2015.

Cape Cod Times. "Arrivederci Roses." August 14, 2000.

Foster, John. "Local Alumni Bring Back Thompson Bros' Clam Bar in Harwichport." Capecodtoday.com, December 15, 2010. http://capecodtoday.com/article/2010/12/15/13391-Local-Alumni-bring-back-Thompson-Bros-Clam-Bar-Harwichport.

Grabmeier, Jeff. "Restaurant Failure Rate Much Lower than Commonly Assumed, Study Finds." *Ohio State Research News*, October 6, 2016. https://researchnews.osu.edu/archive/restfail.htm.

Green, Andrew A. "Landmark Elsie's Sandwich Shop Closes." *Harvard Crimson*, January 6, 1995.

Harvard Crimson. "Elsie's Tradition Endures in Falmouth." October 18, 1983.

Kurth, Austin. "Glory Beneath the Tarnish in Hyannis." *Cape Cod Times,* August 14, 2011.

Maxwell, Trevor. "Burned Diner Left a Legacy." Southcoasttoday.com, November 27, 2000. http://www.southcoasttoday.com/article/20001127/news/311279970.

Milton, Susan. "A Tribute to Thompsons Clam Bar." *Cape Cod Times,* December 30, 2010.

Minsky, Deborah. "Carreiros Hang Closed Sign on Door of Longtime Provincetown Restaurant." *Wicked Local,* May 28, 2013.

———. "Celebration of the Past in Provincetown." *Wicked Local,* May 5, 2012.

Myers, K.C. "Mildreds Grads Savor 30-Year-Old Memories." *Cape Cod Times,* July 21, 2007.

Perry, Jack. "East Bay Landmark Being Torn Down." *Cape Cod Times,* November 11, 1998.

Shemkus, Sarah. "Arrivederci to Abbicci." *Cape Cod Times,* November 22, 2008.

———. "*Asa Bearse House* Goes Up for Sale." *Cape Cod Times,* October 24, 2010.

Wysocki, Heather. "My Tin Man Diner Closed for Good." *Cape Cod Times,* May 8, 2011.

NEWSPAPERS

Barnstable Patriot
Cape Cod Times
Falmouth Enterprise
Harvard Crimson
Wicked Local

WEBSITES

Dunlap, David W. "Bradford Street Extension." Buildingprovincetown. wordpress.com. Accessed September 5, 2016. https://buildingprovincetown. wordpress.com/tag/bradford-street-extension.

———. "1 to 49 Bradford Street." Buildingprovincetown.wordpress.com. Accessed September 5, 2016. https://buildingprovincetown.wordpress.com/tag/1-to-49-bradford-street.

Edward Gorey House. "Biography." Accessed September 11, 2016. http://www.edwardgoreyhouse.org/biography.

Klink, Steve. "About Camp Wellfleet." Campwellfleet.com. Accessed September 25, 2016. http://www.campwellfleet.com.

"Marie Bio." REO Studios.com. Accessed October 6, 2016. http://www.reostudios.com/mariebio.htm.

Orleans Historical Society. "Sam's Scrapbook." Accessed September 5, 2016. http://samsscrapbook.com.

Provincetown History Preservation Project. "Home." Accessed September 5, 2016. http://provincetownhistoryproject.com.

Red Horse Inn. "Why Our Guests Love Us." Accessed September 5, 2016. http://www.redhorseinn.com/about.

Villaggio Ristorante. "Our History." Accessed September 21, 2016. http://www.villaggiocapecod.com/history.html.

Winslow's Tavern. "About." Accessed September 27, 2016. http://www.winslowstavern.com/about.html.

Wychmere Beach Club. "About Us." Accessed September 5, 2016. http://wychmerebeachclub.com/about-us.

ABOUT THE AUTHOR

Christopher Setterlund is a twelfth-generation Cape Codder whose roots go back to the second *Mayflower* voyage. After growing up on Cape Cod and working in the restaurant industry for nearly two decades, he has a wealth of knowledge as to what makes a legendary Cape Cod establishment. He is the author of the In My Footsteps travel book series, which features Cape Cod,

Courtesy of Stephan Drozell.

Martha's Vineyard and Nantucket. In addition to books, the author has contributed work to the Cape Cod Chamber of Commerce, *Cape Cod Life* magazine, *Cape Cod* magazine, Capecod.com and Travel Channel. Away from writing, he is a WITS-certified personal trainer, runner, photographer and lover of travel.